IMAGES
of America

HISTORIC NEWTOWN

Presented by the Newtown Historic Association Inc.
Centre Avenue and Court Street
Newtown, Pennsylvania 18940
http://www.twp.newtown.pa.us/historic/nha.html

The Newtown Historic Association was incorporated in 1964 as an organization dedicated to the preservation of Newtown's heritage. Its headquarters is housed at the Court Inn on the corner of Court Street and Centre Avenue in historic Newtown, Bucks County, Pennsylvania. The Court Inn is one of the oldest and most historic buildings in Newtown. It was the first home of Margaret and Joseph Thornton. It was built as a tavern in 1733 and was a popular gathering place when Newtown was the county seat. The inn has served as the headquarters of the Newtown Historic Association since 1962 and is on the National Register of Historic Places.

On the cover: **INTERIOR VIEW OF THE U.S. BOBBIN AND SHUTTLE COMPANY, C. 1920.** This local business became one of the most prominent among all the manufactories of Bucks County, Pennsylvania. An 1894 advertisement booklet entitled *Newtown Past and Present* reads, "The Excelsior Bobbin and Spool Works, having fitted-up the three story brick building of the Newtown Improvement Company with all the latest and best improved machinery for rapidly turning out all kinds of bobbins and spools, and also for doing general wood turning, they are prepared to fill all orders in above line with promptness and dispatch. Having the facilities of keeping on hand 100,000 feet of thoroughly seasoned lumber, they can guarantee customers the best work at prices in keeping with the market, having on hand a sufficient supply of bobbins and spools to supply the trade. Samples and prices sent on application." (Courtesy of the Newtown Historic Association Inc. See page 59 for more detail.)

IMAGES
of America

HISTORIC NEWTOWN

C. David Callahan, Paul M. Gouza, and Brian E. Rounsavill
for the Newtown Historic Association

ARCADIA

First printed in 2001.

Published by Arcadia Publishing,
an imprint of Tempus Publishing Inc.
2A Cumberland Street
Charleston, SC 29401

Printed in Great Britain.

Library of Congress Catalog Card Number: 2001086553

For all general information contact Arcadia Publishing at:
Telephone 843-853-2070
Fax 843-853-0044
E-Mail sales@arcadiapublishing.com

For customer service and orders:
Toll-Free 1-888-313-2665

Visit us on the internet at http://www.arcadiapublishing.com

HISTORIC NEWTOWN SIGN, C. 1955. This sign was located on Fountain Farm on South State Street near the intersection of old Doublewoods Road. The property is now Newtown Gate. (Courtesy of the Newtown Historic Association Inc.)

CONTENTS

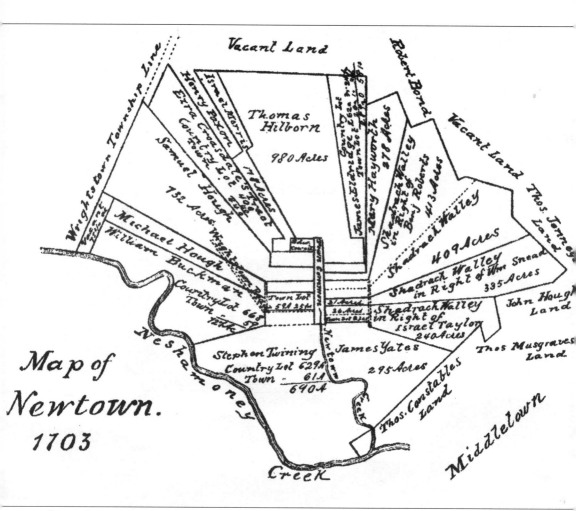

JOHN CUTLER'S 1703 MAP OF NEWTOWN. Cutler's map shows the area that now comprises Newtown Borough, Newtown Township, and the Newtown Commons, for which the boundaries have remained essentially the same. The town was originally planned in a pattern resembling an open fan surrounding a narrow piece of property called the town common, which is located on the Newtown Creek. Local landowners used the town common as a pasture for their livestock and a common gathering area for other town business. (Courtesy of the Newtown Historic Association Inc.)

6

INTRODUCTION

Among the many dreams that have taken hold of the American mind, none is as strong as the nostalgic image of the American small town and the peaceful life it seems to offer. Founded over 300 years ago, Newtown, in Bucks County, Pennsylvania, is the realization of this dream. In this quiet community of shaded streets and Revolutionary War homes, the town and country meet and the world slows down for a life fast vanishing from existence today.

The 5,000 acres that originally comprised Newtown Township were part of the vast tract of land purchased by William Penn from the Native Americans on July 15, 1682. Penn secured this beautiful expanse of pristine real estate in lower Bucks County for a pittance of its inherent worth. It is said that William Penn originally called this area his "New Township," which essentially evolved into "Newtown." Thomas Holme, surveyor for Penn, surveyed the plan of the township and "townstead" in 1684, which outlined 14 farm properties surrounding the central town.

The town was patterned to resemble an open fan surrounding a narrow rectangular piece of property called the town common. The Newtown Creek ran along most of the common, which is situated between State Street and Sycamore Street and which extends from Frost Lane on the north to Penn Street on the south. This area contains a little over 40.5 acres. By mutual agreement, the landowners used the town common to pasture and water their livestock, for public speaking, and for other town business and recreation. As the town's population grew, the common served as a village focal point and helped unite the community. (See page 92.)

Newtown was the scene of some very important events during the Revolutionary War. From this small town on Christmas morning in 1776, Gen. George Washington marched from his headquarters to join the Battle of Trenton. Fairly reliable accounts indicate that Washington made his headquarters here after the Battle of Trenton and the famed crossing of the Delaware River and before the Battle of Princeton. The house that Washington chose as his headquarters, originally constructed in 1757, stood on South Sycamore Street (see page 46). In this private residence, Washington wrote two famous letters to Congress describing the victory at Trenton.

After the Battle of Trenton, Washington used the old Presbyterian church on Sycamore Street as a jail to house several Hessian prisoners (see page 72). In 1778, the Bird in Hand Inn (see page 13), on South State Street, was the site of the only Revolutionary War action to actually occur in Newtown. Here, a skirmish with a detachment of British soldiers took place behind the inn, during which a number of Americans were killed, wounded, or taken prisoner. In addition, large quantities of precious supplies were lost in this famous engagement.

Newtown was the county seat of Bucks County from 1726 until 1813, when it was moved to Doylestown. During this period, this rural community grew into a prosperous government center, leaving behind its origin as an essentially agricultural village. Because a substantial amount of town business had revolved around the courthouse trade, taverns and inns became staples in the local scene. At the beginning of the 19th century, the town was well established as an active and affluent commercial center, supporting tradesmen and artisans in all of the traditional occupations of the time (see page 47). Demand for Newtown's products and services steadily increased during this period, as the town became more widely known throughout the region. Contributing to this distinction was one of Newtown's most prominent citizens, Edward Hicks (1780–1849), the famed primitive artist and Quaker preacher.

As the 19th century progressed, the community remained a busy commercial and cultural center for the surrounding farms. After the county seat was relocated in 1813, Newtown was gradually transformed back into the tranquil pastoral town it once was. In addition to the many historic homes and businesses that line the streets today, one can still sense the industrial and agricultural activity that thrived here so many years ago. What was once rural farmland around Newtown has grown rapidly in the recent past. With the dramatic changes that have taken place over the last 300 years, it is pleasing to see that Newtown has maintained, through a high sense of the importance of its history, its residential village character. Rich in history and abundant with historic charm, Newtown's past exists side by side with the present, and the old has become a part of the new.

Acknowledgments

The photographs that comprise this body of work have been carefully selected to complement, rather than replicate, those that were included in *Early Newtown . . . A Pictorial Presentation of Newtown, Pennsylvania,* published by the Newtown Historic Association Inc. The authors have gone to great lengths to make corrections, additions, and enhancements to the previous publication, while at the same time ensuring the quality, accuracy, and consistency of this work.

This book would not have been possible without the expansive archives of the Newtown Historic Association. The archives have afforded us the rare opportunity to capture everyday life as it was in this rural community as it thrived over a century ago. We would like to take this opportunity to thank the Board of Directors of the Newtown Historic Association for its strong support throughout the completion of this project. This work is our way of showing appreciation to the many other individuals who routinely volunteer their time and energy on behalf of the Newtown Historic Association.

We are also indebted to those who donated photographs from their personal archives: C. David Callahan, Charles C. Waugh, Nancy Trice, Brian E. Rounsavill, Sarah Jane Dallas, and Ann Balderston, as well as the Bucks County Historical Society. The authors would like to acknowledge Michael Donovan, Wes Robinson, Frank Fabian, Frank Carver, and Bob Dafter for their help researching and reviewing many of the captions. Finally, we would like to thank our wives, Mary, Laurie, and Maria, for their patience while many late nights were spent at the Court Inn burning the midnight oil.

In conclusion, we would be remiss if we did not recognize both Norman Kitchin and the late Edward R. "Ned" Barnsley, who over the years have helped contribute to the extensive photographic archives of the Newtown Historic Association. This book is a living testament to the many people, places, events, and circumstances that have shaped the historic culture of our esteemed community.

One
STREET SCENES

The streets of historic Newtown tell a story that spans three centuries—a story that is alive with the people, events, and places that make Newtown one of the treasures of our common American heritage. Originally there were 11 roads leading from the townstead to the surrounding county. Extending like the spokes of a wheel, these thoroughfares followed the boundaries of the various tracts of land that comprised the township (see Cutler's map on page 6). At the time when the courts of Bucks County came to Newtown in 1725, a remark was made that "the roads through Newtown were so unpopular as never to support enough taverns for people attending court." Accordingly, just after the Revolutionary War, as the importance of these roads increased, their names were changed from those of British royalty to those of our Revolutionary War heroes, such as Washington, Jefferson, Greene, Sullivan, Mercer, Sterling, and Barclay. The very names of many streets in Newtown are reminiscent of the deep history that sprang forth from this town, perhaps some of the most vivid reminders that remain today.

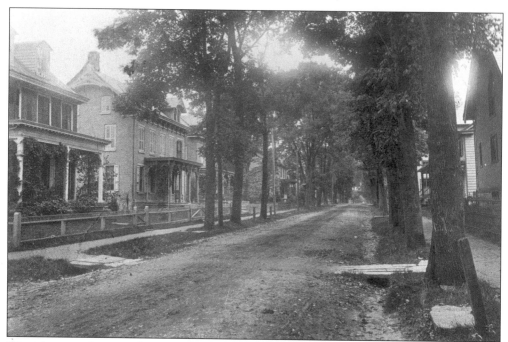

WASHINGTON AVENUE, LOOKING EAST FROM LIBERTY STREET, C. 1890. St. Luke's Episcopal Church Sunday school is on the right. The home on the left is 101 East Washington Avenue. (Courtesy of the Newtown Historic Association Inc.)

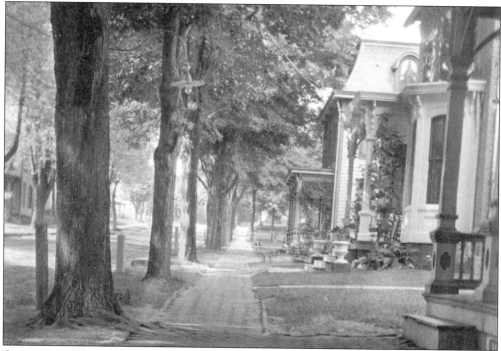

CHANCELLOR STREET, LOOKING NORTH TOWARD WASHINGTON AVENUE. This image was taken on June 11, 1908. The second structure on the right is an Empire-style home at 13 South Chancellor Street. (Courtesy of the Newtown Historic Association Inc.)

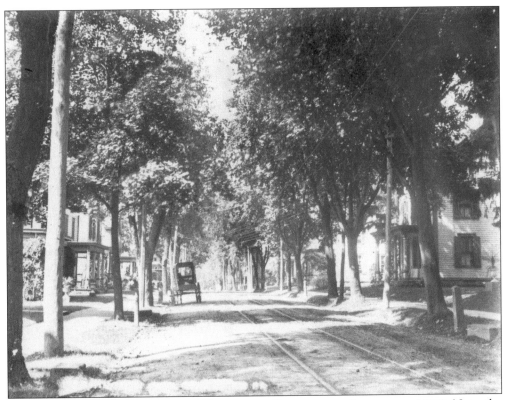

WASHINGTON AVENUE, LOOKING WEST FROM CHANCELLOR STREET, C. 1910. Note the trolley tracks in the middle of the street. The home on the right is 211 East Washington Avenue. (Courtesy of the Newtown Historic Association Inc.)

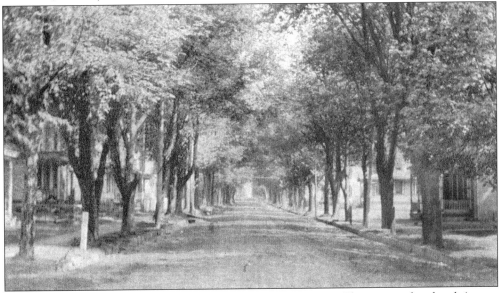

CHANCELLOR STREET, LOOKING NORTH FROM PENN STREET. This postcard is dated August 18, 1913. The home on the far left is 128 South Chancellor Street. (Courtesy of the Newtown Historic Association Inc.)

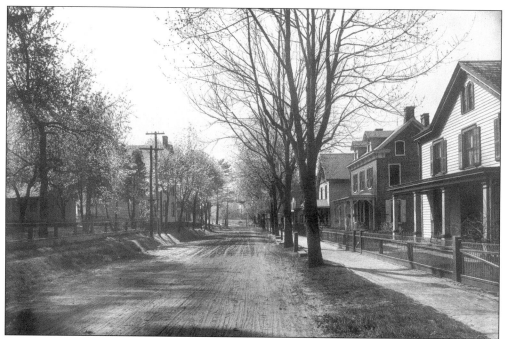

SOUTH STATE STREET, LOOKING SOUTH TOWARD THE "FLATIRON," C. 1910. This location was called the Flatiron because of its shape. On the right are homes at 230 and 234 South State Street. (Courtesy of the Newtown Historic Association Inc.)

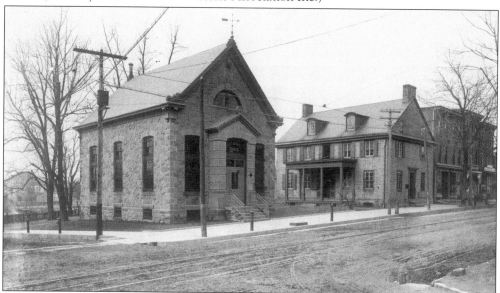

THE SECOND LOCATION OF THE FIRST NATIONAL BANK OF NEWTOWN, C. 1910. The bank moved into this building at the intersection of State Street and Centre Avenue on Monday evening, March 31, 1884. On Tuesday, April 1, the bank was ready for business. A brief article in the *Newtown Enterprise* of April 5, 1884, gives the following account of the new building: "The interior has ample room, both on the floor for its employees and those transacting business, as well as the high ceiling to give ventilation, something the old building lacked." (Courtesy of the Newtown Historic Association Inc.)

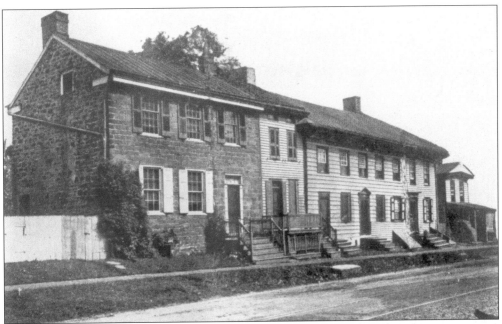

THE BIRD IN HAND INN AND THE JUSTICE HOUSE, C. 1920. These historic structures are located at 107 and 111 South State Street. The Justice House (left) was built in 1768 by Anthony Siddons and served as the quarters of General Sterling during the Revolutionary War. The long frame structure on the right, known as the Bird in Hand Inn, was built in 1726. On the far right is a newer structure, long known as the "Bird Box," but which has since been razed. The narrow dwelling between the inns, since razed, was built by Cyrus Trego in 1867 and stood in a driveway between the taverns. (Courtesy of the Newtown Historic Association Inc.)

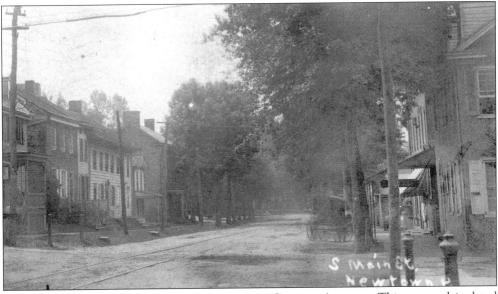

SOUTH STATE STREET, LOOKING SOUTH FROM CENTRE AVENUE. This postcard is dated September 28, 1906. The homes at the left are 103 through 111 South State Street. (Courtesy of the Newtown Historic Association Inc.)

13

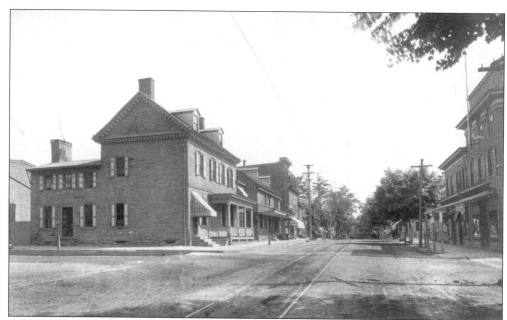

"THE SMOCK HOUSE," SOUTH STATE STREET, LOOKING SOUTH FROM WASHINGTON AVENUE, C. 1910. At the left is 1 South State Street, which is on the corner of Washington Avenue and State Street. (Courtesy of the Newtown Historic Association Inc.)

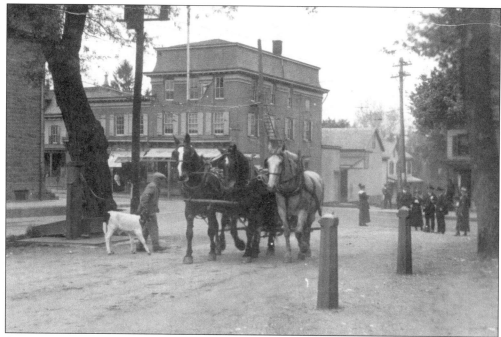

A TEAM OF HORSES IN FRONT OF THE BRICK HOTEL, C. 1900. The people in the background are probably waiting for the trolley, and the calf is possibly being brought to the livestock auction routinely held at the Brick Hotel. (Courtesy of the Newtown Historic Association Inc.)

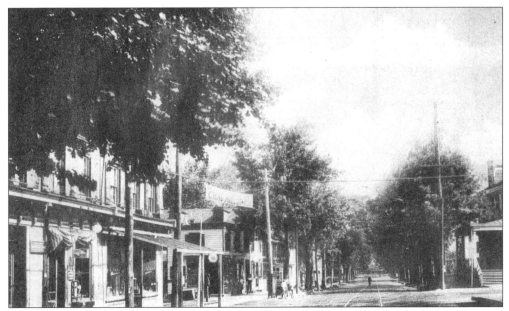

SOUTH STATE STREET, C. 1900. This is a view of 2 South State Street, left, looking north from the intersection of Washington Avenue. (Courtesy of the Newtown Historic Association Inc.)

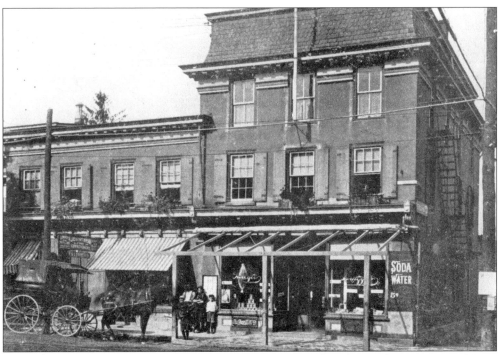

NO. 2 SOUTH STATE STREET, C. 1885. The sign is located at the southwest corner of State Street and Washington Avenue and was used at James Hutchinson's Confectionery Store. Hutchinson also ran the railway and the express business from this same store. The man with the package under his arm is Ed Pownall. (Courtesy of the Newtown Historic Association Inc.)

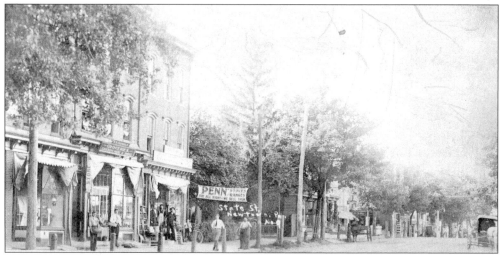

NOS. 35–26 SOUTH STATE STREET, SUMMER OF 1906. In the center of this view, looking north between Centre Avenue and Washington Avenue, is D.B. Chamberlain Groceries, Crockery Ware & Shoes. To the right is J.W. Lundy's store. Shown from left to right are John Baroni (with his grease pot for greasing the trolley curves), Joseph Chamberlain, George A. Hill, J.W. Lundy, Norval Phillips, an unidentified boy, Joseph Gorman, and D. Russell Bond. (Courtesy of the Newtown Historic Association Inc.)

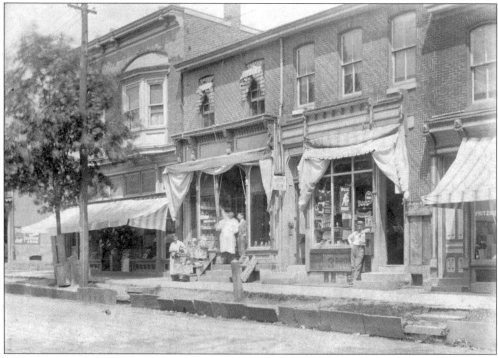

NOS. 25–31 SOUTH STATE STREET BUSINESS DISTRICT, C. 1906. Starting on the far left, the businesses shown in this photograph are Peter H. Morris, Men's Furnishings; the grocery store; Ed Grace's Cigar Store, with the Keystone Telephone office on the second floor; and Fritzider's Notions Store. (Courtesy of the Newtown Historic Association Inc.)

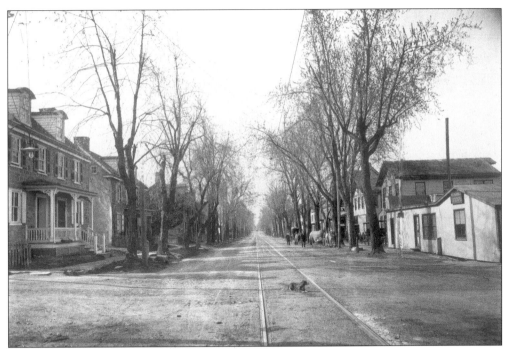

NORTH STATE STREET, C. 1900. This is a view looking south from Jefferson Street. Willie Randall's photography studio is on the right, opposite the residence at 159 North State Street. (Courtesy of the Newtown Historic Association Inc.)

NO. 35 SOUTH CHANCELLOR STREET, C. 1910. Shown in a view from north of Centre Avenue, this Colonial Revival house, the Golden Rod, was built in 1900, as stated in the stone in the sidewalk. (See pages 20 and 36.) (Courtesy of the Newtown Historic Association Inc.)

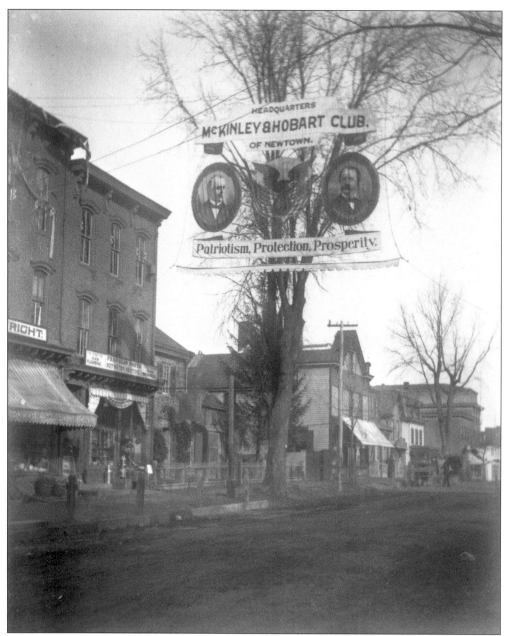

SOUTH STATE STREET, 1896. This view, looking north between Centre Avenue and Washington Avenue, shows 18–30 South State Street during the election parade. McKinley and Hobart were elected president and vice president of the United States in 1896 on the Republican ticket. William McKinley served two terms as president from 1896 to 1901, and Garret A. Hobart served as McKinley's vice president until his death in 1899. McKinley was assassinated in 1901. (Courtesy of the Newtown Historic Association Inc.)

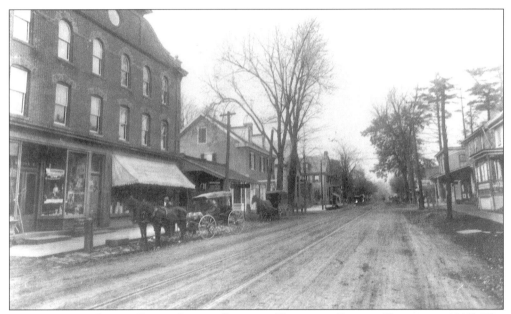

Nos. 100–108 SOUTH STATE STREET BUSINESS DISTRICT, FACING NORTH, C. 1905. The Newtown Hardware House and the old bank building are the first and fourth buildings on the left, respectively (see page 12). The Newtown Hardware House was destroyed by one of the worst fires in Newtown's history on March 4, 1899. It was rebuilt to the exact specifications of the original and reopened by Christmas the same year. (Courtesy of C. David Callahan, Newtown, Pennsylvania.)

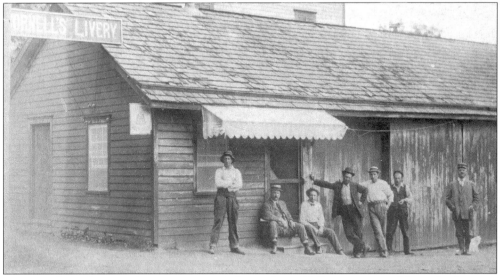

No. 108 EAST CENTRE AVENUE, C. 1910. James Cornell's Livery operated from this location at the turn of the century. The livery offered "driving horses of better sort, suitable for every occasion; carriage riding for pleasure; good single or double teams furnished on short notice, the kind that will please; and two fine, roomy, water-proof moving vans, just as quick, easy and convenient as if you lived in a large city." Note the "telephone pay station" sign offering both of the local telephone services that were in operation at this time. (Courtesy of C. David Callahan, Newtown, Pennsylvania.)

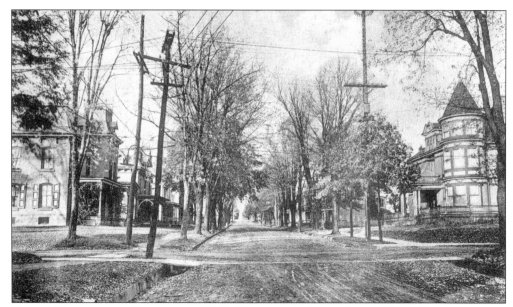

SOUTH CHANCELLOR STREET, C. 1915. This view looks north on Chancellor Street. The home of Annie M. Skeer—35 South Chancellor Street, called the Golden Rod—is pictured on the right. This home was constructed in the summer of 1900. (See pages 17 and 36.) (Courtesy of the Newtown Historic Association Inc.)

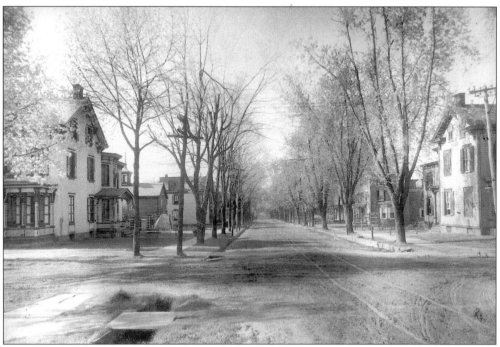

CHANCELLOR STREET, LOOKING SOUTH FROM WASHINGTON AVENUE, C. 1895. A steeple can be seen on top of the carriage house, the second building on the left. The early power-telephone wires have remained virtually unchanged (except for the pairing) for 100 years. (Courtesy of Charles C. Waugh, Tarzana, California.)

STUCKERT BUILDING, DURING THE 1915 FIREMAN'S PARADE. This building is located at 11 East Centre Avenue on the corner of Court Street and Centre Avenue. The rear building dates to 1882 and the Stuckert Building to 1910. Note the natural gas company truck in the left foreground. (Courtesy of the Newtown Historic Association Inc.)

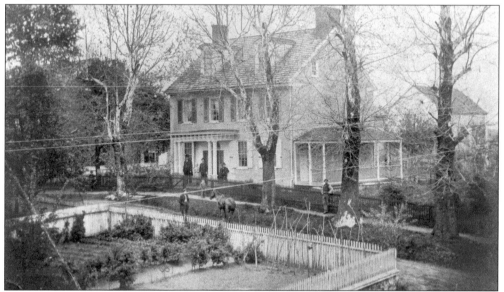

NO. 35 COURT STREET, C. 1880. This home is located on the northeast corner of Centre Avenue and Court Street. The photograph was taken from the roof of Dan Cahill's Blacksmith Shop. It is evident that a garden existed where the Stuckert Building now stands. This building dates from c. 1772. It was constructed by Bernard Taylor and was the home and store of Gen. Francis Murray. General Murray was the only Newtown Revolutionary War soldier to be captured and taken prisoner twice. (Courtesy of the Newtown Historic Association Inc.)

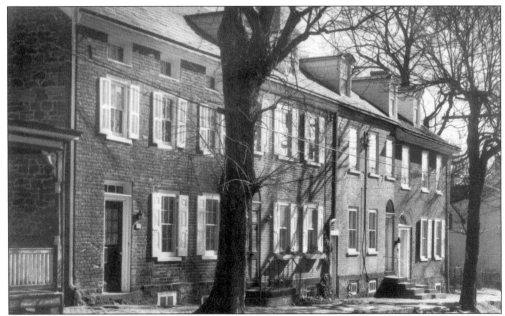

NOS. 107–113 COURT STREET, C. 1930. Margaret Thornton constructed the house on the left, 107 Court Street (the Thornton-Hicks House), in 1782. After Thornton's death in 1790, the property was purchased by Abraham Chapman, a prominent attorney at the time. It was then sold to famed primitive artist Edward Hicks (1780–1849), who resided at this address from 1811 to 1821. (Courtesy of the Newtown Historic Association Inc.)

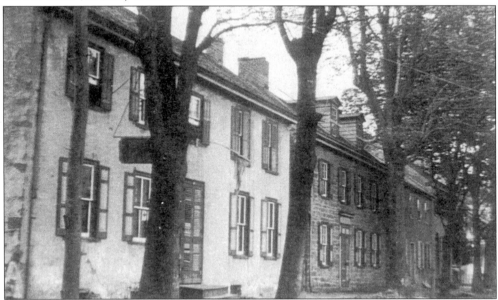

NOS. 121–129 COURT STREET, C. 1905. This photograph shows an area of Court Street between Mercer and Penn Streets. Joseph Worstall built the stone house in the middle c. 1774. In this general area, Worstall operated a tanyard, or tannery, a thriving business of that day where hides were prepared for leather making. It is related that George Washington, when headquartered in Newtown, had a pair of boots made at the Worstall shops. (Courtesy of the Newtown Historic Association Inc.)

Two
EARLY STRUCTURES

Newtown is a living museum of architectural history. It possesses examples of major architectural styles dating from the late 17th century to the 20th century. The 18th-century buildings are generally grouped on what was the courthouse tract, located near the corner of Court Street and Centre Avenue. Even today they give the impression of the original small Colonial village. Buildings of later architectural style extend from the original village, generally in chronological order, to the periphery of the town. In 1796, Newtown had about 50 dwellings, and tradition indicates that one house in ten, in addition to the keeper of the jail, had a license to sell liquor. Among the oldest buildings in the town are those erected for taverns or inns, as these establishment were prominent factors in life at the time.

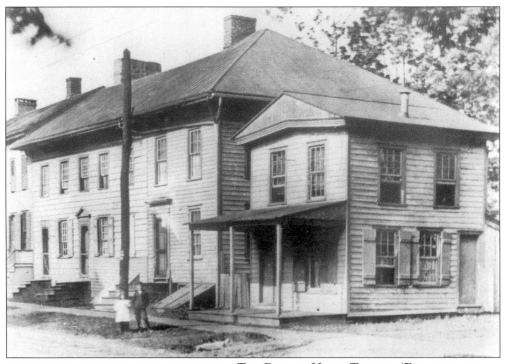

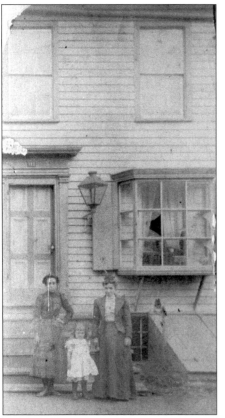

THE BIRD IN HAND TAVERN (FORMERLY THE RED LION INN), C. 1870. This 17th-century frame structure, located at 111 South State Street, is believed to have been built by George Welch between 1726 and 1728, following the erection of the county buildings. The inn is the oldest frame structure in Pennsylvania and was the home of Shadrach Walley, Newtown's first settler. This building was the site of the only Revolutionary War action to take place in Newtown. It also housed Newtown's first post office, and it was in this inn that the Newtown Reliance Company for the Detection and Apprehension of Horse Thieves and Other Villains was founded in 1819. This company is Newtown's oldest organization. It is still in operation today, with over 300 members meeting annually. (Courtesy of the Newtown Historic Association Inc.)

SOUTHERN END OF THE BIRD IN HAND, C. 1880. A bay window was added after the previous photograph had been taken. (Courtesy of the Newtown Historic Association Inc.)

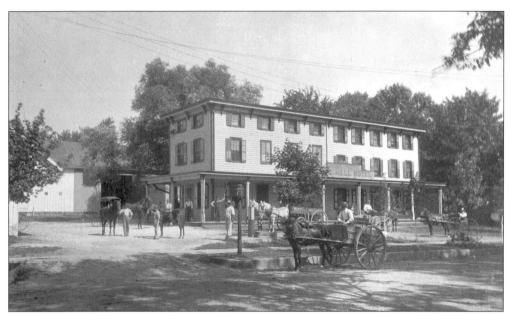

THE WHITEHALL HOTEL, C. 1880. This hotel, located at 127 South State Street, was operated by Daniel Y. Harmon *c.* 1860–1862. It was gutted by fire in 1979 and restored to its original facade in the 1980s. Note the town pump on the green in the foreground. (Courtesy of the Newtown Historic Association Inc.)

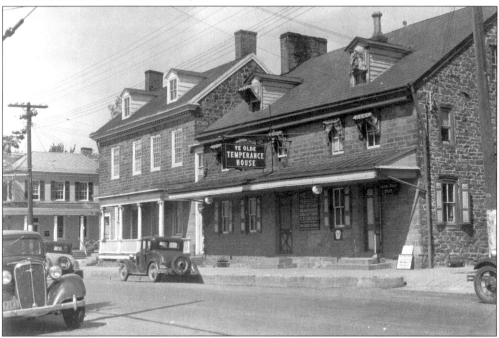

YE OLDE TEMPERANCE HOUSE, C. 1940. Andrew and Nancy McMinn built the first part of the present inn, located at 5 South State Street, *c.* 1772. Part of the building was used as a tavern and another section as a schoolhouse, where Andrew McMinn taught. McMinn became a well-known figure in Newtown history. During the Revolutionary War, he served as a sergeant in Capt. Henry Van Horn's militia. (Courtesy of the Newtown Historic Association Inc.)

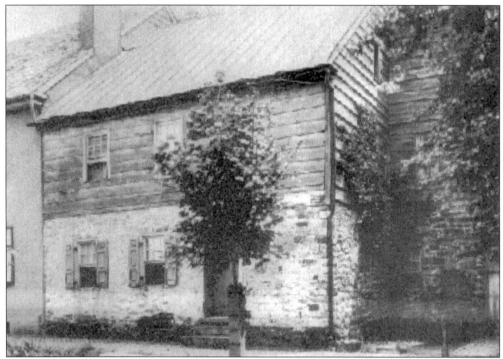

THE COURT INN, 1906. The Court Inn—located at 5 Court Street at the intersection of Court Street and Centre Avenue—is the headquarters of the Newtown Historic Association. This photograph was taken by J. Pemberton Hutchinson. (Courtesy of Nancy Trice, Dawson Springs, Kentucky.)

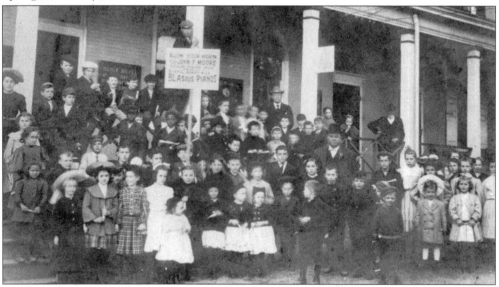

SCHOOLCHILDREN, C. 1920. Pictured is a group of schoolchildren in front of the Brick Hotel, located at the intersection of Washington Avenue and State Street. Some of those identified in the photograph are Emma Bebbs, Emma Fuhrur Ettinger, Lillian Smith, Lewis Wetling, Fanny Carver, Violet Tombs, Lillian Carver, Helen Dyer, Bob Craig (the owner of the Brick Hotel), and the piano promoter (in the derby hat). (Courtesy of the Newtown Historic Association Inc.)

THE OLD COUNTY COURTHOUSE BUILDING LOT, C. 1900. The house in the foreground was built on the foundation of the old courthouse building, on the lot on the west side of Court Street just north of Centre Avenue. In 1822, this structure was converted into a carriage factory and used for many purposes. On the second floor, the Siloam Lodge of Odd Fellows was started in September 1847. In the background, the outlines of the prison and the keeper's house are visible. (Courtesy of the Newtown Historic Association Inc.)

AN AERIAL VIEW OF THE INTERSECTION OF WASHINGTON AVENUE AND STATE STREET. This photograph was taken on September 15, 1941, by Walter Lefferts. The Brick Hotel, Dick Olsen's Oldsmobile Garage, Higgins Brothers' Stable for the sale of horses, and the outhouses (right) are all clearly visible. (Courtesy of the Newtown Historic Association Inc.)

THE JAMES YATES HOUSE, C. 1880. This house was located near 258 South State Street and was razed in 1897. James Yates's son, James Yeates, was one of the three participants of the famed Walking Purchase with Native Americans in 1737. In order to determine the northernmost boundary of Bucks County, the Native Americans agreed to grant as much land as could be covered in a day-and-a-half walk. In an effort to gain as much land as they could, these men resorted to running instead of walking. Said to have been attributed to the exhaustion from running, James Yeates died only three days later. (Courtesy of the Newtown Historic Association Inc.)

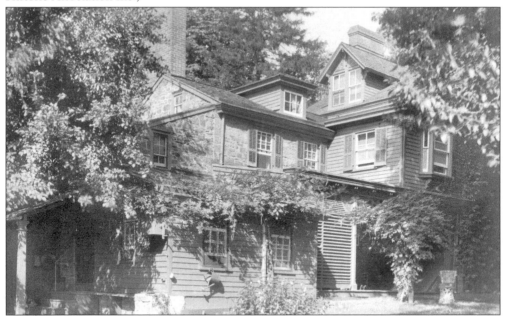

THE ROSS-HESTON HOUSE, C. 1920. Thomas Ross built the front, newer part of this home at 212 South State Street in 1798. It is said that Ross and his wife did not live very happily together. As divorce was not common then, Ross relieved the situation by building the front part of the house for his wife and making it entirely separate from the back part, which he occupied. There was no passage between the front and the back part of the house on the second floor until one was made much later by later occupants, Dr. and Mrs. Heston. The house was razed in the 1960s. (See page 31.) (Courtesy of the Newtown Historic Association Inc.)

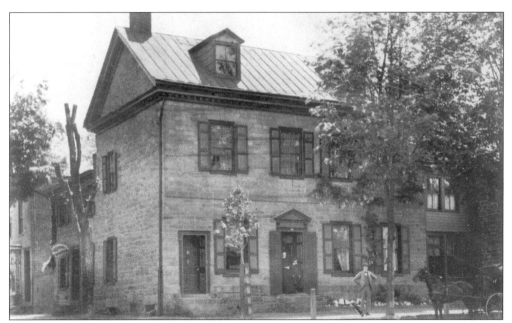

THE SMOCK HOUSE, C. 1900. This home is located on the southeast corner of State Street and Washington Avenue and for many years was the home of Dr. Charles B. Smith. Mrs. Smith and Morell Smith are in the doorway. Morell Smith was the only Newtown man killed in World War I. The American Legion post in Newtown took its name from this local hero. (Courtesy of the Newtown Historic Association Inc.)

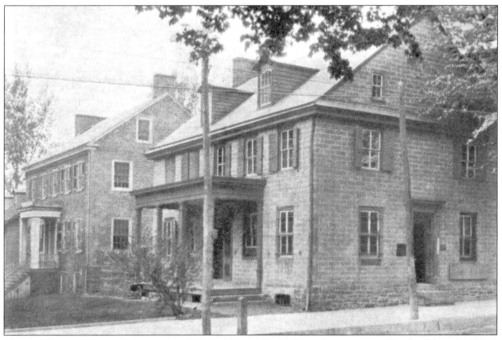

NO. 34 SOUTH STATE STREET, C. 1910. Originally built as the county office building in 1796, this attractive structure currently houses the First National Bank of Newtown trust offices. It is just north of Centre Avenue. (Courtesy of the Newtown Historic Association Inc.)

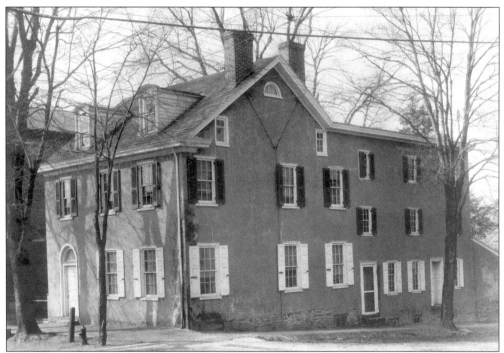

No. 100 South State Street, c. 1865. This house is located at the southwest corner of State Street and Centre Avenue. It was the home of Phineas Jenks, the first president of the Bucks County Medical Society. Jenks was also elected as a delegate from Bucks County to the Constitutional Convention in 1837. (Courtesy of the Newtown Historic Association Inc.)

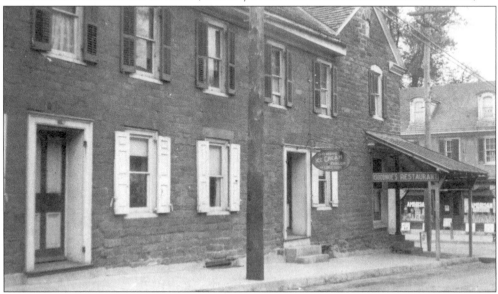

The Thornton House, c. 1910. This house is located at 101 South State Street on the corner of Centre Avenue and State Street. It was purchased in 1754 by Margaret Thornton, owner of the Court Inn. In 1772, the home was purchased by Francis Murray, a prominent citizen and soldier in the Revolution. He and his family operated a general store here. (Courtesy of the Newtown Historic Association Inc.)

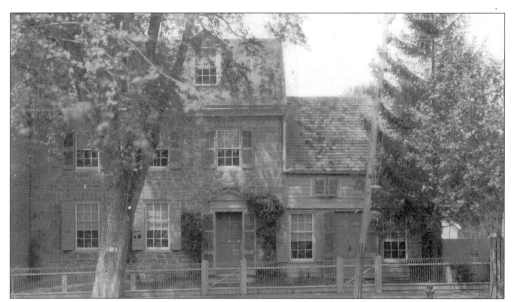

THE LINTON HOUSE, 1897. The Linton House, built in 1796 and located at 22–24 South State Street, is now located behind the Arcade Building, which was built in 1917. If one stands directly across the street on the sidewalk, the dormers from the original structure are visible. They are the only remaining visible exterior features of the original building. (Photograph by Willie Randall, courtesy of the Newtown Historic Association Inc.)

THE HOME OF DR. HESTON, C. 1920. This house was located at 212 South State Street. In 1885, owing to poor health, Dr. Heston relinquished his practice to Dr. J. Aubrey Crewitt of Huntingdon, Pennsylvania. (Courtesy of the Newtown Historic Association Inc.)

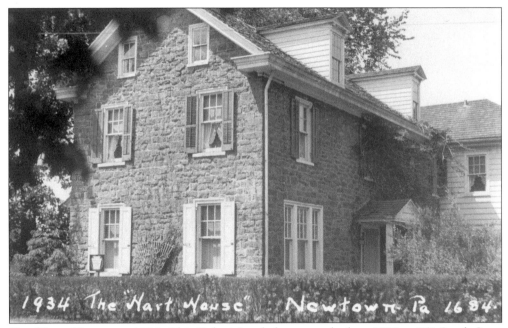

THE HART HOUSE, C. 1930. This Colonial-style home was built *c.* 1719 at 252 South State Street. On October 22, 1781, the notorious Doane Gang took John Hart, treasurer of Bucks County, from this home at gunpoint up the street to the county treasury building, where they robbed the entire treasury. Legend has it that the money has never been found and is buried somewhere in Bucks County. (Courtesy of the Newtown Historic Association Inc.)

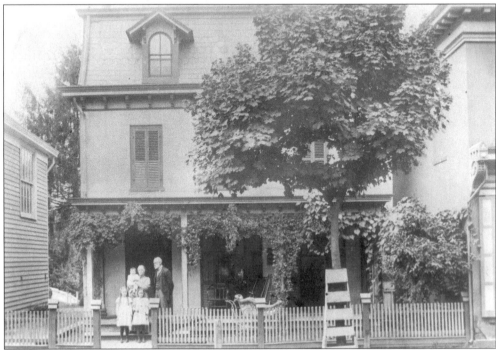

NO. 10 SOUTH STATE STREET, C. 1910. At the time, this house was the home of Dr. Howard A. Trego, dentist. (Courtesy of the Newtown Historic Association Inc.)

No. 309 Washington Avenue, c. 1880. This framed Victorian Gothic home was built c. 1870. The Chancellor Street School is in the background. (Courtesy of Charles C. Waugh, Tarzana, California.)

The Home of Dr. Parry, c. 1910. This house was at 18 East Washington Avenue on the corner of Court Street and Washington Avenue, where the St. Luke's Episcopal Church Sunday school building now stands. It was razed in 1953. (Courtesy of the Newtown Historic Association Inc.)

No. 203 East Washington Avenue, c. 1900. This Victorian Gothic home, built in 1850 on the northeast corner of Congress Street and Washington Avenue, served as the Presbyterian manse. In 1862, Presbyterian elder William Slack bequeathed money for the construction of the manse. (Courtesy of the Newtown Historic Association Inc.)

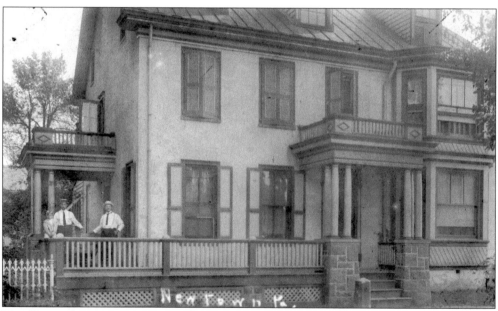

The Fretz Property, c. 1910. This stone home was also located at 100 East Washington Avenue, where the St. Luke's Episcopal Church Sunday school building now stands. It stood between the church and St. Luke's house before it was razed in 1958. It was given to the church by the Chambers family. (Courtesy of the Newtown Historic Association Inc.)

THE ARCHAMBAULT HOUSE, C. 1910. Located at 115 East Washington Avenue, this house was built in the 1830s by Joseph Archambault. Its French-style ornamental grillwork was cast at the old iron foundry in Newtown. It has been said that Archambault Square served as a station on the Underground Railroad during the Civil War. (Courtesy of the Newtown Historic Association Inc.)

THE BARNSLEY RESIDENCE, C. 1888. Called Locust Grove, this home was built at the east edge of Newtown Borough at 547 East Washington Avenue. Revolutionary War hero John Barnsley built this stone house c. 1795, and the frame addition was constructed in 1862 by his grandson, who was also named John Barnsley. Shown in the photograph are the latter John Barnsley, Mrs. John Barnsley (seated), daughter Wilhelmina (on the steps), and daughter Mary (leaning against the fence). (Courtesy of the Newtown Historic Association Inc.)

THE WISTERIA HOUSE, C. 1900. This brownstone Tuscan Villa–style home, located at 32 South Chancellor Street at the intersection of Chancellor Street and Centre Avenue, was built in 1874. It was constructed of the same brownstone as the Chancellor Street School, which came from the Buckman Quarry along the Neshaminy Creek, where Tyler Park now stands. (Courtesy of the Newtown Historic Association Inc.)

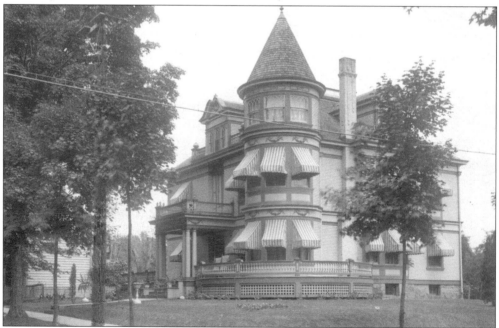

NO. 35 SOUTH CHANCELLOR STREET, "THE GOLDEN ROD," C. 1910. Annie M. Skeer built this house in the summer of 1900. (See pages 17 and 20.) (Courtesy of the Newtown Historic Association Inc.)

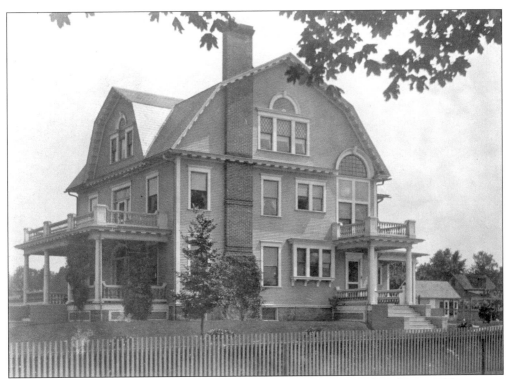

No. 125 NORTH CHANCELLOR STREET, C. 1905. This Dutch Colonial Revival home was built in 1902 for J. Herman Barnsley. (Courtesy of the Newtown Historic Association Inc.)

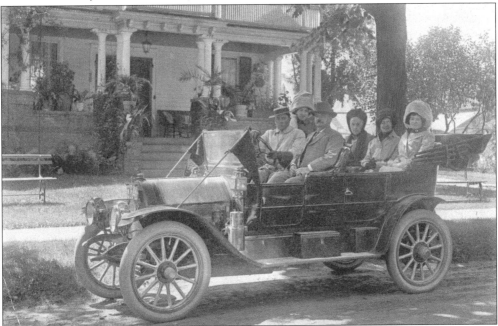

THE BARNSLEY RESIDENCE, C. 1918. An automobile is parked at 125 North Chancellor Street, with Mr. and Mrs. Tressler and Mr. Geist, the chauffeur. (Courtesy of the Newtown Historic Association Inc.)

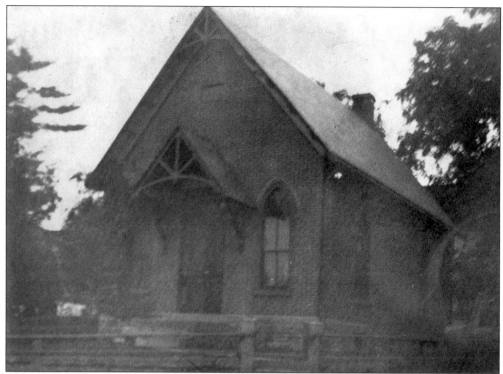

THE SECOND SITE OF THE NEWTOWN LIBRARY COMPANY, C. 1890. The Hennessey Building, formerly the Stuckert Building, was built in 1882 at 11 East Centre Avenue on the corner of Court Street and Centre Avenue. The peak of the building is still visible today over the top of the building that was constructed in front of it in 1912. (Courtesy of the Newtown Historic Association Inc.)

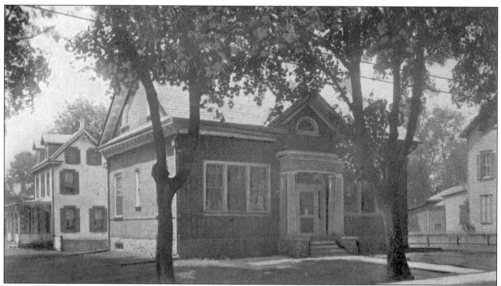

THE NEWTOWN LIBRARY COMPANY, C. 1915. This 1911 building is located at 114 East Centre Avenue at the corner of Centre Avenue and Congress Street. The library is the second oldest private library in Pennsylvania. (Courtesy of the Newtown Historic Association Inc.)

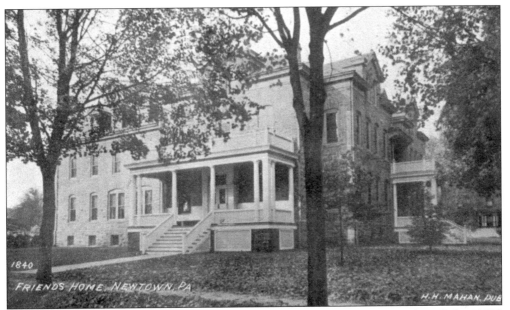

THE FRIENDS BOARDING HOME, C. 1915. Judge Edward M. Paxon endowed this 1899 Romanesque boardinghouse, located on the northwest corner of Centre Avenue and Congress Street. (Courtesy of the Newtown Historic Association Inc.)

NO. 35 SOUTH CONGRESS STREET, C. 1895. Alexander Blaker built this Colonial brick house in 1836. (Courtesy of the Newtown Historic Association Inc.)

STONEHURST, C. 1900. Isaac W. Hicks built Stonehurst, located at 123 Penn Street, in 1833 directly across the street from the home of his father, Edward Hicks. (Courtesy of the Newtown Historic Association Inc.)

NOS. 98–100 PENN STREET, C. 1895. This structure was built in 1874 as the Worstall Stables and was converted into two separate dwellings in 1981. (Courtesy of the Newtown Historic Association Inc.)

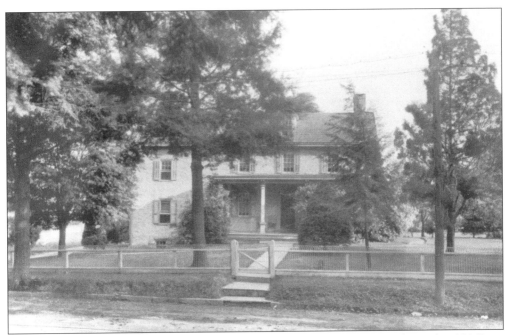

THE HICKS HOUSE, C. 1910. The former home of painter Edward Hicks is located at 122 Penn Street. Hicks's subjects included farmscapes and biblical scenes. He painted more than 50 versions of *The Peaceable Kingdom*, which was based on a prophecy of Isaiah. Hicks was also a coach, a sign painter, and a Quaker preacher. (Courtesy of the Newtown Historic Association Inc.)

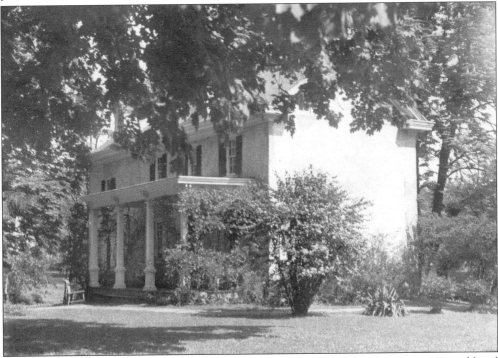

THE HICKS HOUSE, LOOKING EAST, C. 1910. Edward Hicks built this home in 1821 and lived here until his death in 1849. (Courtesy of the Newtown Historic Association Inc.)

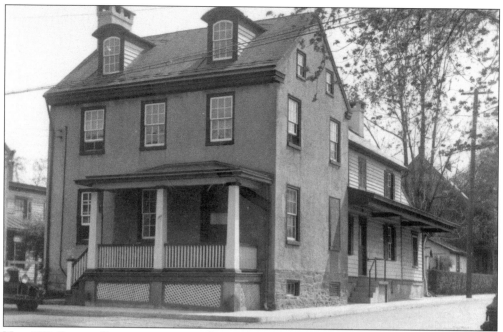

No. 129 Court Street, c. 1930. This Colonial home, on the corner of Court and Penn Streets, was built in 1770. (Courtesy of the Newtown Historic Association Inc.)

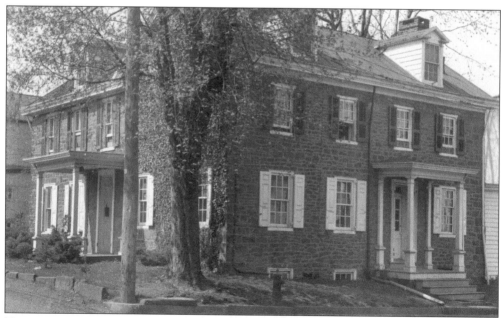

No. 200 Court Street, c. 1930. This Federal- and Popular-style home was originally owned by County Cornwall, a freed slave. Cornwall bought what was probably the early section in 1791 from Margaret Thornton, proprietor of the Court Inn. (Courtesy of the Newtown Historic Association Inc.)

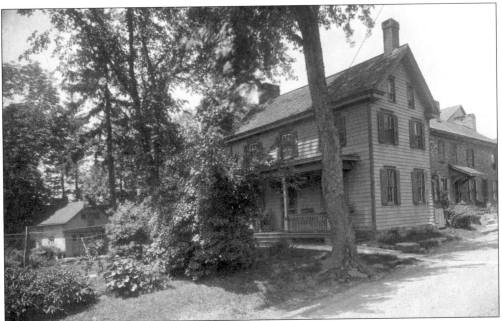

No. 226 Court Street, c. 1925. Situated on the Flatiron, across the street from the Friends Meetinghouse, this home was the site of the Old Yellow School. In 1811, carpenter Levi Bond was contracted by the county to do carpentry work on the "new public buildings" to prepare for the move of the county seat from Newtown to Doylestown. (Courtesy of the Newtown Historic Association Inc.)

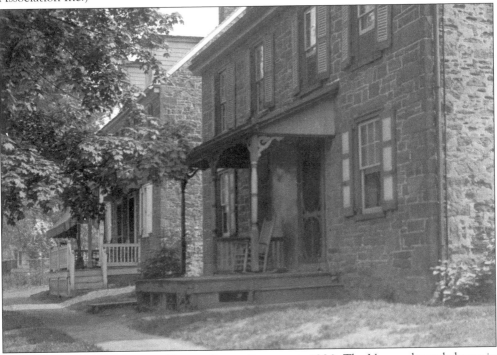

Houses on the East Side of North State Street, c. 1930. The Vernacular-style home in the foreground is at 155 North State Street. (Courtesy of the Newtown Historic Association Inc.)

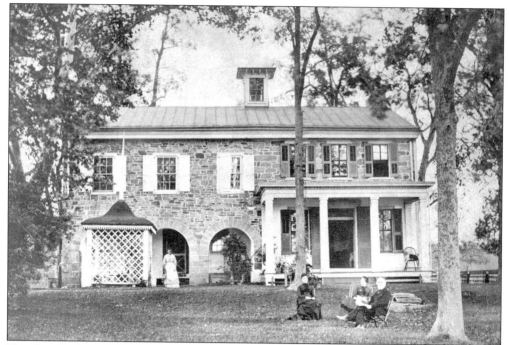

THE SOUTH SIDE OF WILLOW HILL FARM, C. 1880. Located at 473 Lower Dolington Road in Newtown Township, this house was built by the Yardley family on a 100-acre tract in 1751. The people are identified as "Grandfather," "Grandmother," Frances E. Wayne, and Sarah Morgan (maid). The dog on the porch was named Dick. (Courtesy of the Newtown Historic Association Inc.)

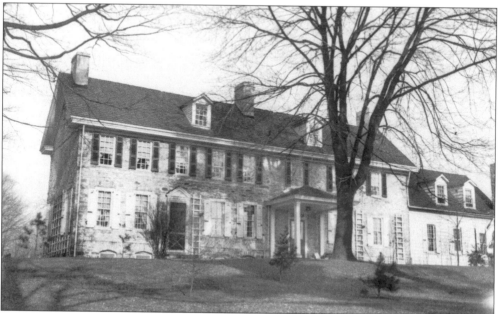

SOUTHERN VIEW OF TEMORA FARM, JANUARY 1937. This Georgian-style home, located at 372 Swamp Road in Newtown Township, was built in 1750. (Courtesy of the Newtown Historic Association Inc.)

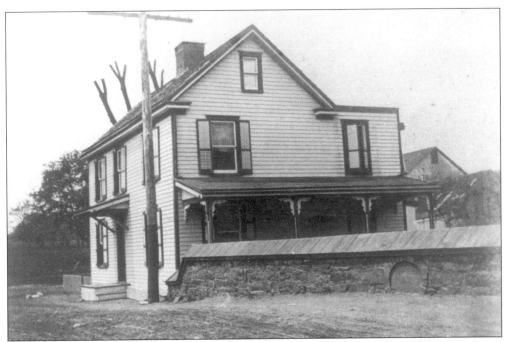

THE MCMASTERS HOUSE, C. 1900. This building was named after one of its early owners, Robert McMasters, a blacksmith. McMasters built the house c. 1863 on West Centre Avenue. (Courtesy of the Newtown Historic Association Inc.)

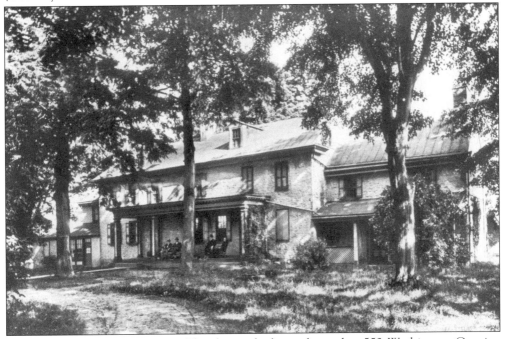

SPRING BROOK FARM, C. 1890. This farm, which was located at 552 Washington-Crossing Road and was later converted into the Lavender Hall restaurant, was constructed c. 1730. This photograph was taken after the Taylor family owned this property, but before it was restored as a restaurant. (Courtesy of the Newtown Historic Association Inc.)

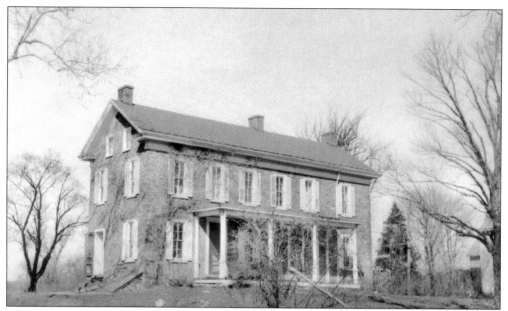

WASHINGTON'S HEADQUARTERS, C. 1900. Located at the intersection of Swamp Road and Sycamore Street, the brownstone house in this photograph was razed in 1965. George Washington used the previous structure at this location as his headquarters after the Battle of Trenton in 1776, and it was at that house where he penned his two letters to Congress, giving them the official report of the Battle of Trenton. The original structure was completed in 1757 and razed in 1862, according to General W.W.H. Davis. Alexander German built the house shown here, the third on the site, during the Civil War. The house is said to have been built out of the stone from the original Washington's Headquarters House. (Courtesy of the Newtown Historic Association Inc.)

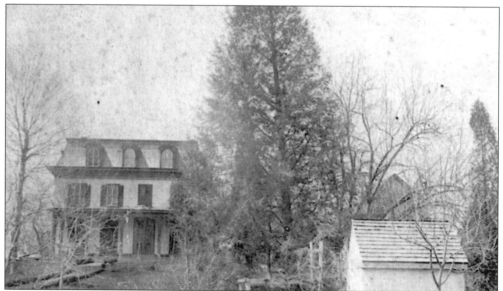

THE BUCKMAN HOUSE, C. 1880. This Victorian home, located at 2 Swamp Road at the intersection of Swamp Road and Sycamore Street, was built c. 1860 around a smaller, core home. (Courtesy of Charles C. Waugh, Tarzana, California)

Three

BUSINESSES

The commercial center of early-18th-century Newtown was on land just south of the courthouse tract on Court Street near Centre Avenue. James Yates, the first settler of this tract (see page 28), sold small lots to persons wanting them for improvement. A gristmill, first store, blacksmith shop, and two tanyards were early commercial enterprises. In the early 1800s, Newtown was an active and thriving commercial center, probably without rival in the Bucks County area aside from Bristol. The list of taxable inhabitants documents one wheelwright, one schoolmaster, one printer, one silversmith, one cooker, one miller, one butcher, one physician, one harness maker, one hatter, two carpenters, three shopkeepers, three tanners, three tailors, four weavers, four blacksmiths, five innkeepers, five attorneys, five masons, seven shoemakers, and sixty-five farmers. During the 19th century, the commercial area spread northward along State Street, which forms the heart of Newtown's business district today.

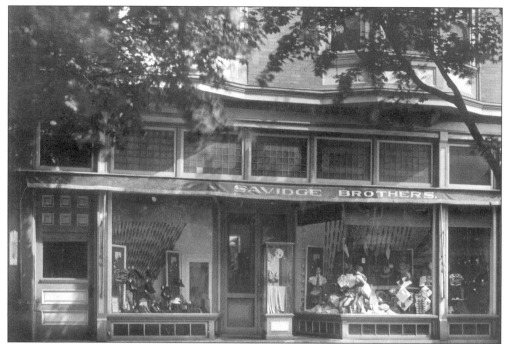

SAVIDGE BROTHERS MEN'S FURNISHINGS STORE, C. 1930. This store, built in 1906 by Peter H. Morris, is located at 25 South State Street. In 1922, Peter H. Morris went into partnership with his nephews Morris and Clarence Savidge until he retired in 1928 due to ill health. Notice the freestanding center display unit at the entrance of the store. This store operated until the late 1970s. (Courtesy of the Newtown Historic Association Inc.)

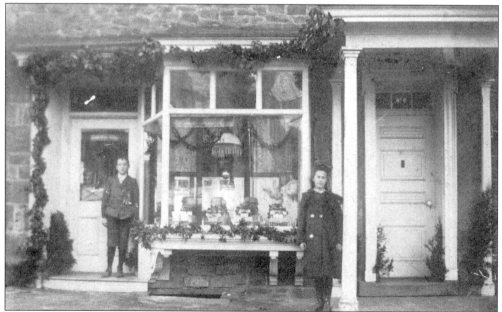

THE A. SCHORSCH BAKERY, C. 1920. This store was located at 6–8 North State Street. Note that the store was decorated for Christmas. The boy on the left is unidentified. The girl is Jane Hutchinson Milnor. (Courtesy of the Newtown Historic Association Inc.)

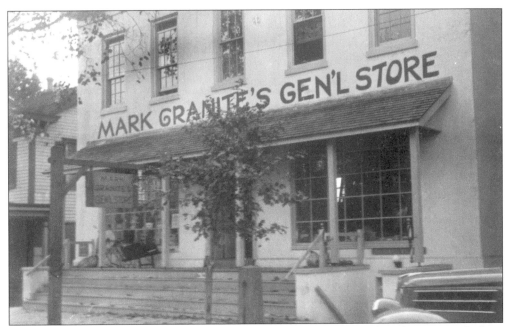

MARK GRANITE'S GENERAL STORE, C. 1932. This store was located in the present Godwin Building at 110 South State Street. Mark Granite was the commander of the New Guard, a radical group that opposed the views of Pres. Franklin Roosevelt. Each week, Granite delivered a "Granitegram" to 100 homes, together with another piece of official Republican literature. (Courtesy of the Newtown Historic Association Inc.)

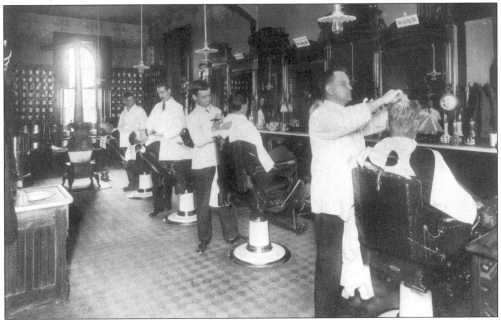

CLAYTON KELLER'S BARBERSHOP, C. 1930. This barbershop was located in the same building. Note the shaving mugs on the back wall, the potbellied stove, and the sign indicating that the price of a haircut was only 20¢. Shown from left to right are Joe Gumper, John Weasner, Bill Gourley, and Clayton Keller. (Courtesy of the Newtown Historic Association Inc.)

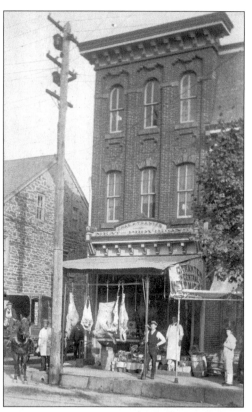

CHARLES H. TRANTOR, MEATS AND PROVISIONS, C. 1910. Located at 11 South State Street, this store was built on the site of Joseph B. Roberts Tinware and Stove Store. The location is now the lobby entrance to the Temperance House Inn. (Courtesy of the Newtown Historic Association Inc.)

HORACE A. EFFRIG'S MEATS AND GROCERIES, C. 1920. Effrig's was located at 27 South State Street. Horace Effrig entered the meat and grocery business at an early age with his father in Philadelphia. He moved to Newtown in 1917 and operated this business into the 1940s. (Courtesy of the Newtown Historic Association Inc.)

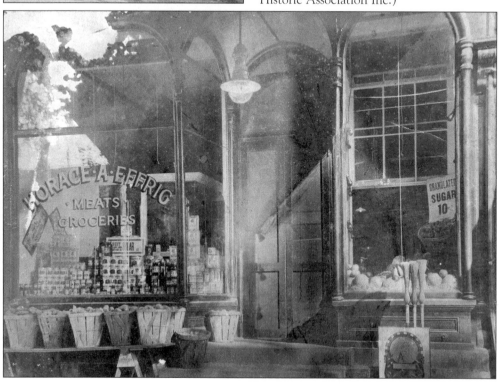

CHARLES H. TRANTOR, MEATS AND PROVISIONS, C. 1900. This store, which had bright-red trim, was located at 11 South State Street. Pictured in this photograph are, from left to right, John Trainer, Walter Scott, Charlie Trantor, Mark Worthington, and two unidentified men. (Courtesy of the Newtown Historic Association Inc.)

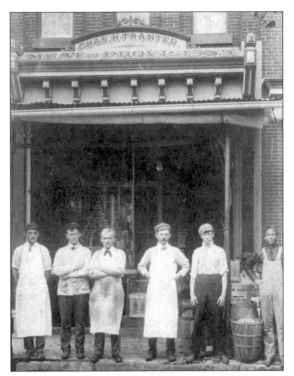

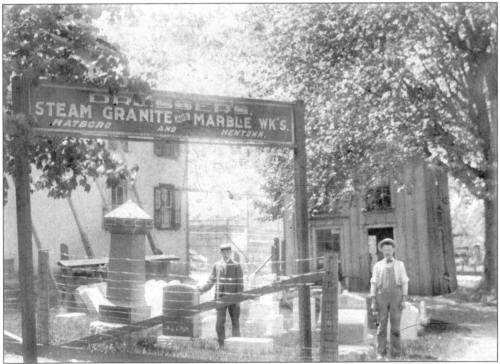

DRESSER'S STEAM GRANITE AND MARBLE WORKS, C. 1895. This stone monument factory was located at 103 North State Street at the intersection of Greene Street. (Courtesy of the Newtown Historic Association Inc.)

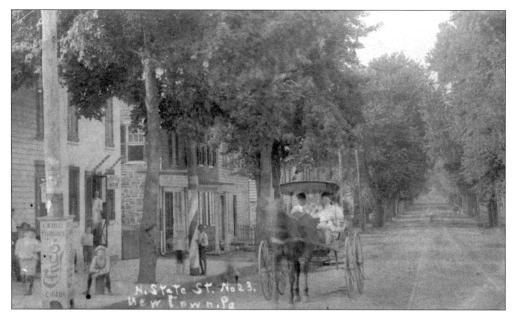

NOS. 2–8 NORTH STATE STREET BUSINESS DISTRICT, C. 1900. At the left is the D.C. Voorhees Cigars and Tobacco shop at 2 North State Street. That building was razed in 1925. Note the two striped barber poles over the door of the next shop. The third business is the A. Schorsch Bakery. (Courtesy of the Newtown Historic Association Inc.)

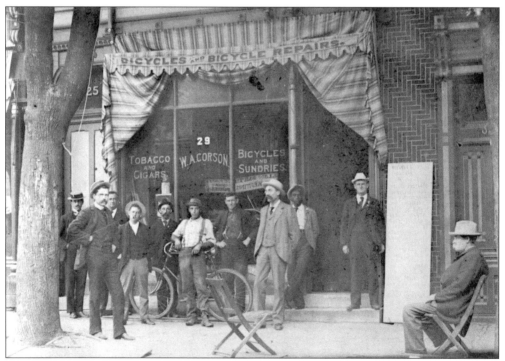

THE W.A. CORSON TOBACCO AND CIGAR STORE, C. 1890. This store was located at 29 South State Street. (Courtesy of the Bucks County Historical Society.)

MCCARTY'S CIGAR STORE, C. 1925. Located at 2 North State Street, this building was razed shortly after this photograph was taken. (Courtesy of the Newtown Historic Association Inc.)

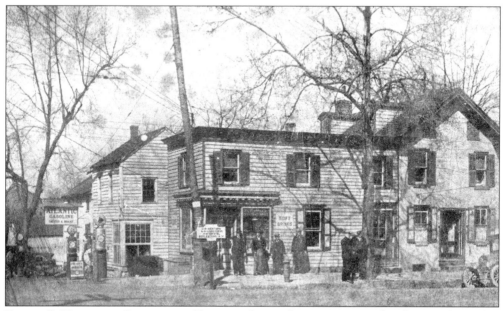

DAVID C. VOORHEES CIGARS AND TOBACCO SHOP, APRIL 2, 1928. This shop was located at 2 North State Street on the corner of State Street and Washington Avenue. The building was moved *c.* 1930 to 5 West Washington Avenue to make room for the Newtown Title and Trust building. It was then moved for a second time north of this location and was later razed. Pictured, from left to right, are David C. Voorhees, John Voorhees, Frank Miller, Jimmy Hutchinson, Bob Croasdale, and Joe Herrod. (Courtesy of the Newtown Historic Association Inc.)

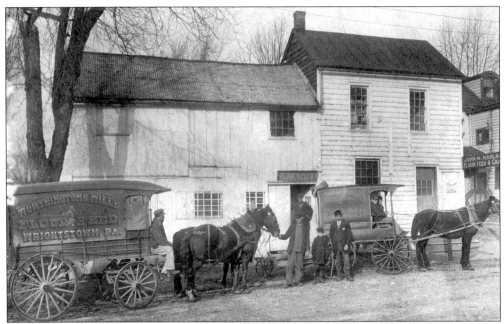

JOHN M. HARLAND FLOUR, WHEAT, AND GRAIN, C. 1890. This business was located near 5 West Washington Avenue. Shown from left to right are an unidentified driver, Ed Powers in the doorway, Frank Heath, an unidentified boy, John Harland, John McCue, and Ed Burns. (Courtesy of the Newtown Historic Association Inc.)

THE WORSTALL BROTHERS & COMPANY ICE WAGON, C. 1910. This photograph was taken just north of 156 North State Street in front of Willie Randall's photography studio. (Courtesy of the Newtown Historic Association Inc.)

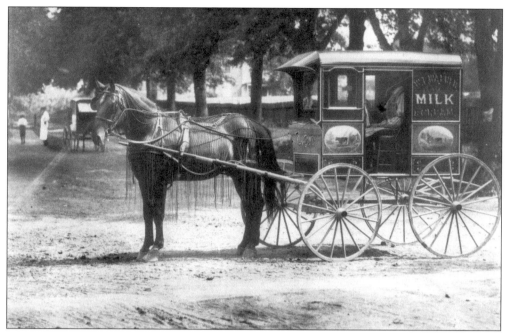

THE MILK WAGON OF THE W. WALKER DAIRY BUSINESS, C. 1890. This photograph was taken at the intersection of State Street and Jefferson Avenue. The dairy business was located on Court Street. The J.V. and C. Randall Carriage Company of Newtown made this milk wagon. (Courtesy of the Newtown Historic Association Inc.)

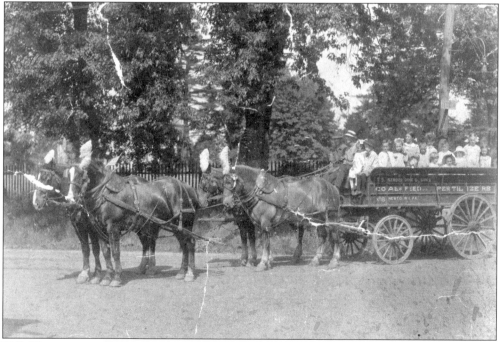

T.S. KENDERDINE COAL, FEED, AND FERTILIZERS DELIVERY WAGON, C. 1900. This wagon, filled with children, was photographed on South State Street. (Courtesy of the Newtown Historic Association Inc.)

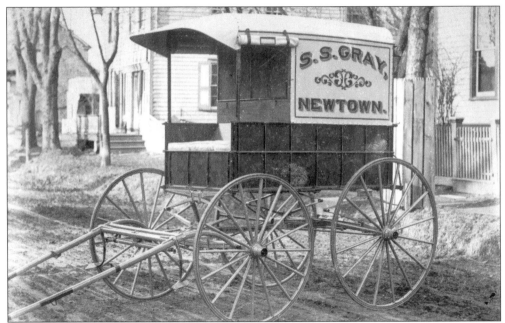

A BRAND NEW DELIVERY WAGON BUILT FOR S. SCOTT GRAY, C. 1880. This photograph was taken at 212 South State Street in front of the Warner and McGowan wagon manufacturing business. S. Scott Gray ran a slaughterhouse on Penn Street east of the cemetery until Robert Kenderdine purchased it in 1899. Kenderdine reportedly moved the building to his property on South State Street. (Courtesy of the Bucks County Historical Society.)

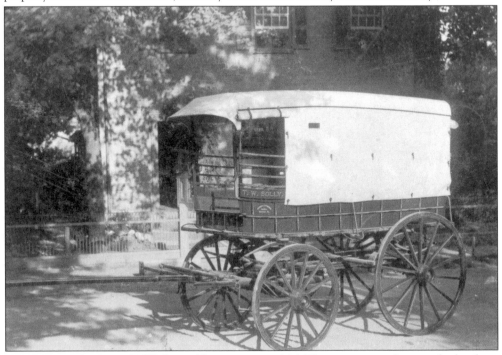

A DELIVERY WAGON OF T.W. SOLLY ENTERPRISES, 1906. This wagon was photographed in front of the Heston House at 212 South State Street. (Courtesy of the Bucks County Historical Society.)

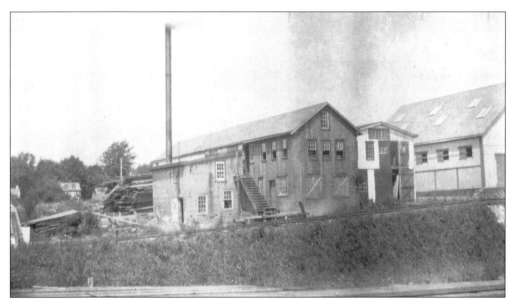

DAVE WATSON'S SASH AND BLIND FACTORY, C. 1890. This factory, later known as the A.W. and W.M. Watson Lumber and Mill Work, was located at 17 South Lincoln Avenue. (Courtesy of the Newtown Historic Association Inc.)

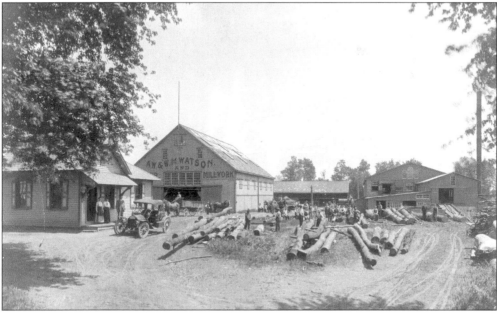

A.W. & W.M. WATSON LUMBER AND MILLWORK, C. 1920. Located at 17 South Lincoln Avenue, this establishment was founded in 1872. Buildings owned by this company were twice destroyed by fire in 1882 and 1905, but the company has remained in continuous operation since its founding. (Courtesy of the Newtown Historic Association Inc.)

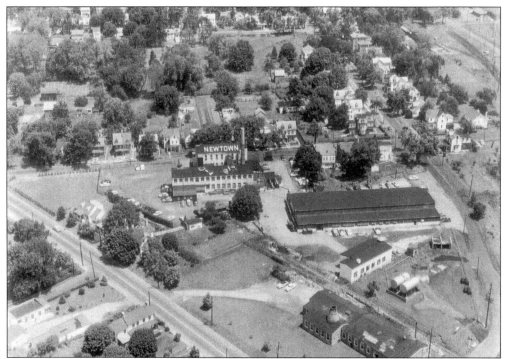

AN AERIAL PHOTOGRAPH OF SOUTH STATE STREET, C. 1950. Notice the advertisement for "Newtown" which was prominently displayed on the roof of the Stocking Works at 301 South State Street. (Courtesy of the Newtown Historic Association Inc.)

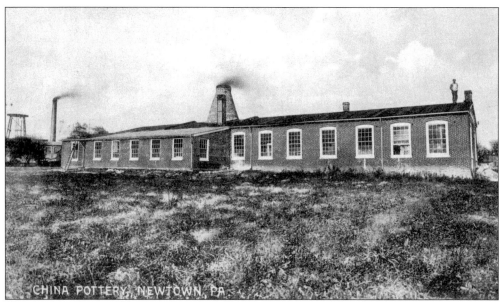

THE NEWTOWN CHINA POTTERY FACTORY, C. 1900. This factory, located at 451 South State Street, operated from about 1890 until the 1930s. It specialized in a variety of pottery ranging from fine china to utilitarian household items such as porcelain door knobs and bathroom fixtures. (Courtesy of the Newtown Historic Association Inc.)

THE EXCELSIOR BOBBIN AND SPOOL WORKS, 1893. The wood turning business originally known as Mawson Brothers operated at 301 South State Street on the South Side of Sterling Street from 1892 to 1928. (See page 2.) Some individuals in the photograph are Charles Arnwine, George Hofmeister, Arthur Tomlinson, William Hofmeister, James Mawson, Charles Mawson, ? Balderston, John Rempher, John Mawson, Bill Mawson, Charles Rempher, and Elmer Watkins. (Courtesy of the Newtown Historic Association Inc.)

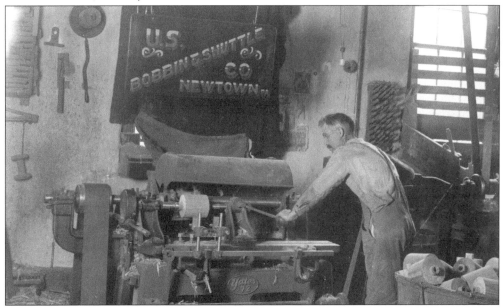

AN INTERIOR VIEW OF THE U.S. BOBBIN AND SHUTTLE COMPANY, C. 1920. Formerly the Excelsior Bobbin and Spool Works, this company was run out of the building that is the now the Stocking Works at 301 South State Street. The building also housed the Lavelle Aircraft Company from 1940 to the 1960s. The Excelsior Bobbin and Spool Works was founded by John B. Mawson in Yardley in 1884. It moved to Newtown eight years later by his sons James, William, and Charles after a fire destroyed the Yardley plant. In 1904, the bobbin and spool works formed a stock combination and chartered the name Excelsior Bobbin and Spool Company, which expanded with new buildings and updated equipment. (Courtesy of the Newtown Historic Association Inc.)

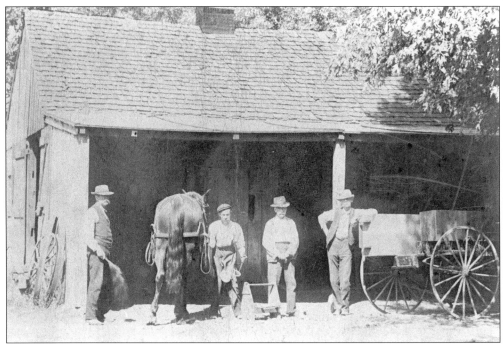

WES DYER'S BLACKSMITH SHOP, C. 1899. This shop was located near 9 South Sycamore Street, just north of Centre Avenue. Pictured from left to right are ? Conover, Sylvester Dyer (blacksmith), Elias Morris, and unidentified. (Courtesy of the Newtown Historic Association Inc.)

ROBERT M. PIDCOCK'S BLACKSMITH SHOP, C. 1877. Bob Pidcock ran a blacksmith shop in the barn behind his house at 422 Washington Avenue. In 1877, new shoes cost $1.25 per set, and removing was 12¢ per shoe. (Courtesy of the Newtown Historic Association Inc.)

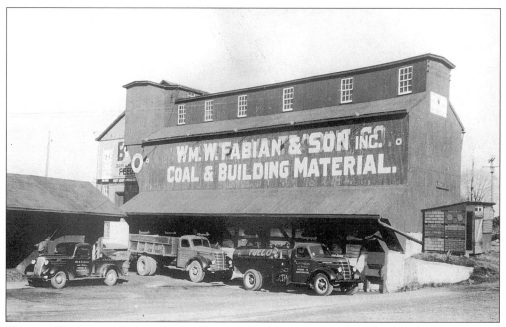

WILLIAM W. FABIAN & SON, INCORPORATED FUEL OIL, C. 1938. This business has been located on 507 South State Street since 1909. (Courtesy of the Newtown Historic Association Inc.)

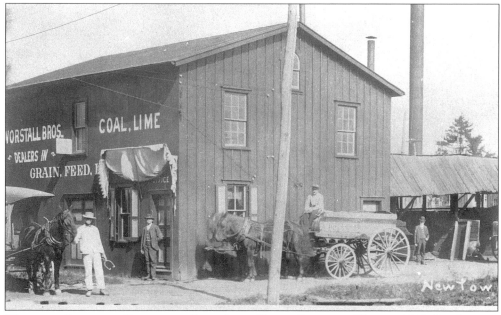

WORSTALL BROTHERS, DEALERS IN COAL, LIME, GRAIN, FEED, AND HAY, C. 1890. This business was located at 507 South State Street. (Courtesy of the Newtown Historic Association Inc.)

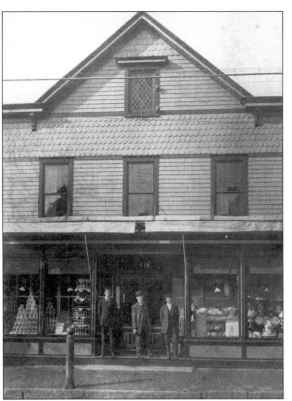

THE MIDDLE STORE, C. 1910. Proprietors John Stapler and W. Kirk Carver ran the store at 18 South State Street. (Courtesy of the Newtown Historic Association Inc.)

ANOTHER VIEW OF THE MIDDLE STORE, C. 1865. The Middle Store, located at 18 South State Street, was built by James Racquet and was run by a succession of storekeepers through the 19th century. Although the image has not held up to the test of time, this photograph is one of the oldest in the archives of the Newtown Historic Association. (Courtesy of the Newtown Historic Association Inc.)

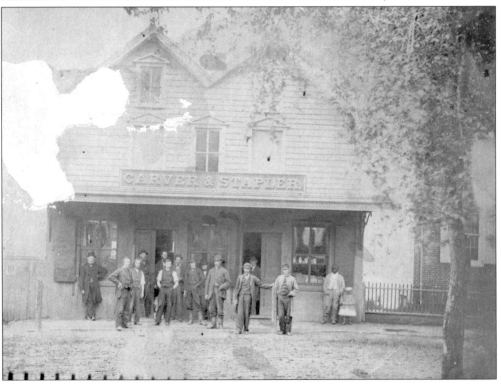

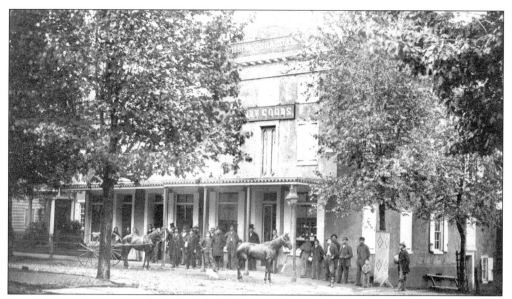

THE WILSON CROASDALE STORE, C. 1865. This business was located at 2–4 South State Street on the Southwest corner of Washington Avenue and State Street. Notice the box-type guards that prevented the horses from eating the bark off the trees while the patrons shopped. (Courtesy of the Newtown Historic Association Inc.)

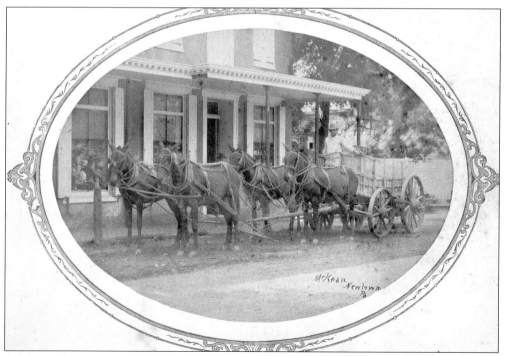

A MULE TEAM IN FRONT OF CROASDALE STORE, C. 1880. This store was located 2 and 4 South State Street on the southwest corner of Washington Avenue and State Street. (Courtesy of the Newtown Historic Association Inc.)

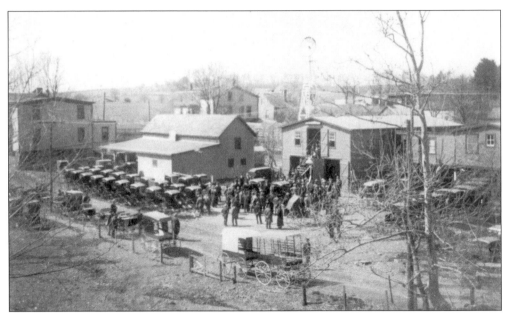

THE JEFFERSON STREET BRIDGE, 1905. The J.V. and C. Randall Carriage Works held an annual spring wagon and carriage sale. This view is looking west on Jefferson Street from atop the Randall carriage factory. (Courtesy of the Newtown Historic Association Inc.)

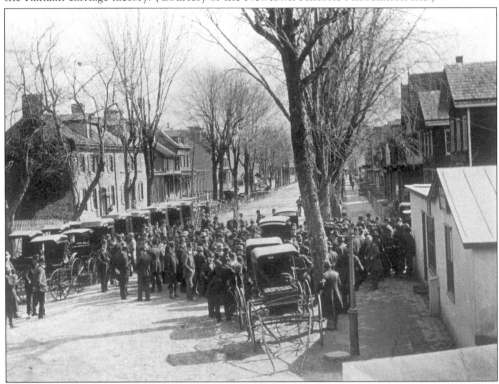

THE ANNUAL SPRING CARRIAGE SALE AT J.V. AND C. RANDALL'S, C. 1890. This business was located at 156 North State Street. The view is facing south. (Courtesy of the Newtown Historic Association Inc.)

Four

RELIGION

Many of the early houses of worship in Newtown had similar beginnings. Circuit riders of every faith rode through the area and no doubt held services, which were never recorded. People attended religious services in neighboring towns until a few of them banded together to establish their own houses of worship here. Newtown Hall served as the site of various church services while the growing congregations raised money to get their own church buildings started. Churches, of course, were not merely bricks, stones, and buildings; they were people, and the story of religion in Newtown is really the story of courage, cooperation, and sacrifice of its citizens.

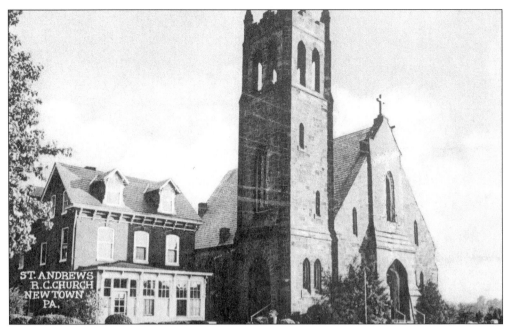

OLD ST. ANDREW'S CHURCH, C. 1930. The 70-foot bell tower for this church on South Sycamore Street was completed in 1910. The bell was dedicated to St. Margaret in memory of the donor, Margaret Farrell. The church is built in modern Gothic style of dressed stone, quarried along the Neshaminy from the Mitchill Quarry. (Courtesy of the Newtown Historic Association Inc.)

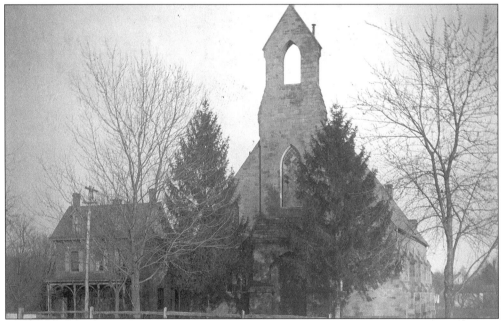

OLD ST. ANDREW'S CHURCH, C. 1906. This photograph was taken before the completion of the bell tower shown in the previous picture. The cornerstone was laid on November 16, 1873, and the completed church was dedicated by the Most Reverend Frederick Wood, archbishop of Philadelphia, on June 13, 1880. (Courtesy of the Newtown Historic Association Inc.)

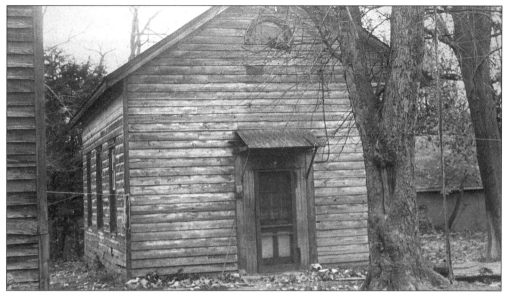

JOHN WESLEY AME CHURCH, C. 1890. This church was located behind 146 North Congress Street, near the present St. Mark AME Zion Church. St. Mark's Church was originally called the John Wesley AME Church and was founded in Newtown *c.* 1820. Soon afterward, a small frame meetinghouse was built at the corner of Frost Lane and Congress Street. Around 1840, the building, high on the hill overlooking Newtown, burned; the fire could be seen for miles. This gave way to the nickname Light House Hill. The church's cemetery remains on this spot. The second structure was built at the intersection of Frost Lane and State Street, but that building also burned in 1857. This frame structure was the third and was erected on North Congress Street. It was supplanted by the present brick church, which was built by Rev. James Henry Hardin in 1897 and dedicated in April 1898. (Courtesy of the Newtown Historic Association Inc.)

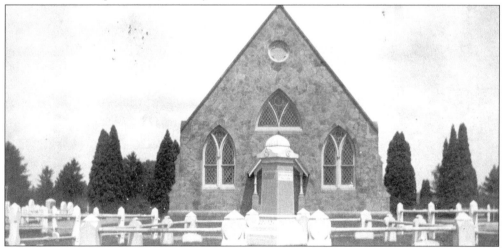

THE CEMETERY CHAPEL AT THE NEWTOWN CEMETERY, 1897. In 1880, the cemetery managers decided to build a chapel for the nonsectarian burial ground. Located at the intersection of Washington and Elm Avenues, the building was designed by Francis Surnay. George S. Mahon was hired to erect the red stone chapel. The total construction cost was $2,593.50. The last surviving Civil War veteran from Pennsylvania, Charles Duckworth (1847–1949), is buried here. (Courtesy of the Newtown Historic Association Inc.)

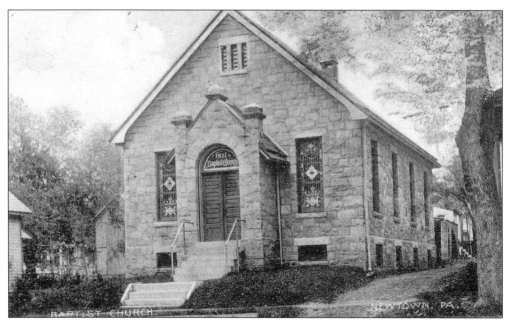

FIRST BAPTIST CHURCH, APRIL 12, 1910. Early services for this congregation were held in Newtown Hall and then in Smith's Hall on Washington Avenue near State Street. After a sermon by Reverend Romine in Newtown Hall on Sunday, September 22, 1901, a business meeting was held for the purpose of organizing a church in Newtown. Ground was broken for this church on September 25, 1905, and it was dedicated in May 1906. The church is located at 25 North State Street on a lot known as "Gas House Lot." It was procured for $500, and construction costs added up to approximately $5,000. (Courtesy of the Newtown Historic Association Inc.)

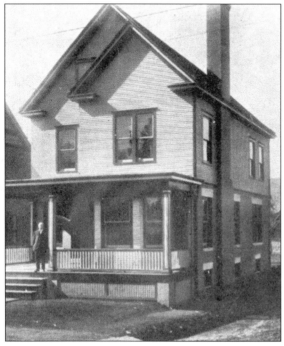

PARSONAGE OF NEWTOWN'S METHODIST EPISCOPAL CHURCH, c. 1920. This church is located at 30 North Congress Street. In 1907, Annie Skeer presented the church with a parsonage located at the corner of Congress and Greene Streets. (Courtesy of the Newtown Historic Association Inc.)

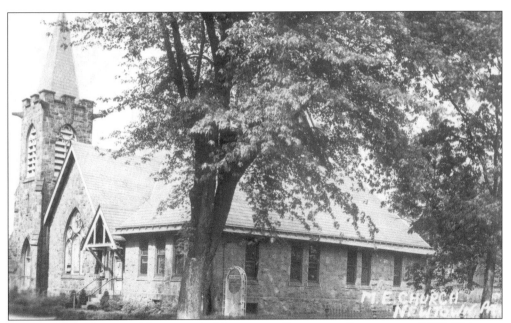

THE SECOND HOME OF NEWTOWN'S METHODIST EPISCOPAL CHURCH, C. 1905. This new church, at Liberty and Greene Streets, was dedicated on Sunday, November 22, 1896. Built of Neshaminy brownstone, the Gothic structure incorporates a square steeple, 12 by 12 feet, rising 68 feet over the main entrance. (Courtesy of the Newtown Historic Association Inc.)

FIRST HOME OF NEWTOWN'S METHODIST EPISCOPAL CHURCH, C. 1870. This structure was located on the corner of Liberty and Greene Streets. At the quarterly conference held at Pennsville on June 4, 1842, a committee was appointed to estimate the cost of a house of worship in Newtown. Although there is no information on the steps taken to build the church, the original structure, known as Wesley Hall, was completed in 1846 on the east side of Liberty Street. (Courtesy of the Newtown Historic Association Inc.)

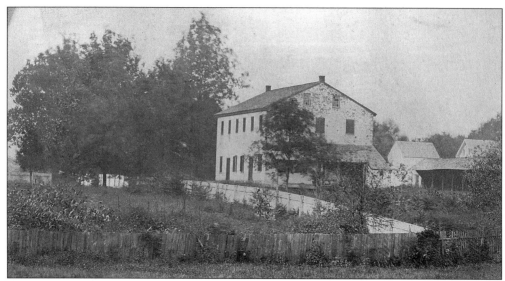

THE NEWTOWN FRIENDS MEETINGHOUSE, C. 1875. This is a view from the southeast of the meetinghouse, which is located on Court Street. In 1815, under the leadership of Edward Hicks, the Newtown Friends took over the abandoned courthouse on Court Street as their house of worship. The site was available because the county seat had moved to Doylestown one year earlier. Two years later, in 1817, the present meetinghouse was built on Court Street. Edward Hicks was the guiding spirit in planning and fundraising for the building and was the first to preach in the new building. (Courtesy of the Newtown Historic Association Inc.)

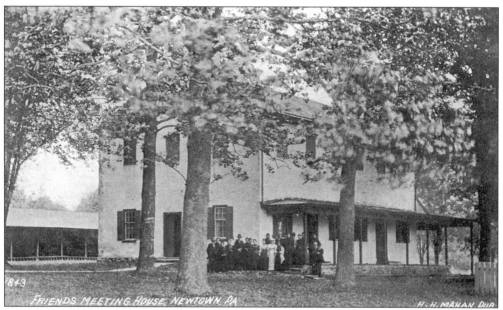

NEWTOWN FRIENDS MEETINGHOUSE, C. 1910. Located on Court Street, the Friends Meetinghouse is a large primitive building, with the exterior of its walls smeared with white plaster and the interior marked by pure simplicity. The grave of Edward Hicks (1780–1849) is located in the cemetery on the right. (Courtesy of the Newtown Historic Association Inc.)

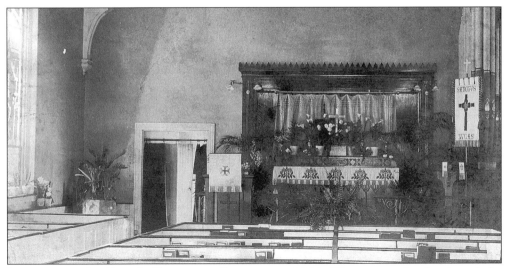

INTERIOR OF ST. LUKE'S EPISCOPAL CHURCH, C. 1925. The present focal point of the sanctuary at St. Luke's is the 15th-century altarpiece, one of only two in the United States, cast from an original by the Italian master Andre della Robbia. The church contains beautiful gifts that were given to St. Luke's in 1932 by Ada B. Reeder in memory of her husband, Horace Reeder. These gifts include a painting called *The Coronation of the Virgin*, a mother-of-pearl baptismal shell inlaid with gold, and an enamel processional cross created in the Holy Land. (Courtesy of the Newtown Historic Association Inc.)

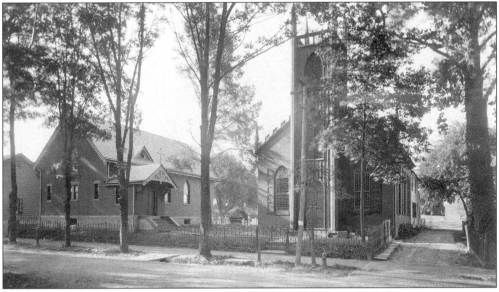

ST. LUKE'S EPISCOPAL CHURCH, 1903. Located in the 100 block of Washington Avenue, the original church was built on land purchased on December 12, 1832, from James Phillips for $240. The church was consecrated in 1836. The original wood tower (shown) was erected in 1855 and was replaced in 1904 by the present brick tower. The parish house, to the left, was erected in 1893 and demolished in 1953 when it was replaced by St. Luke's House at the corner of Washington Avenue and Court Street. Visible at the back of the church is the framed sexton's house, built in 1835 and replaced in 1929 by the present brick sacristy. (Courtesy of the Newtown Historic Association Inc.)

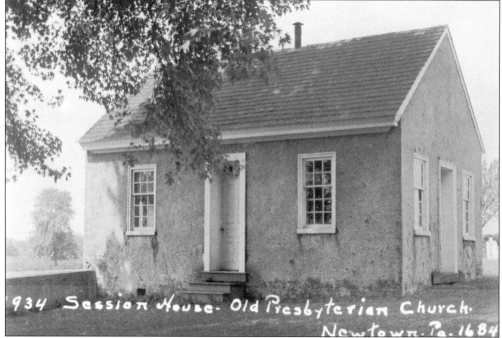

In image: '934 Session House. Old Presbyterian Church. Newtown. Pa. 1684

THE OLD PRESBYTERIAN CHURCH SESSION HOUSE, 1934. Located on Sycamore Street, this is one of only two session houses that still stand in Bucks County. In the early 1800s, the session house was built to accommodate the ruling elders of the church, who were farmers from either the Makefields or Newtown Township. This is also where meetings were held on Sundays. (Courtesy of the Newtown Historic Association Inc.)

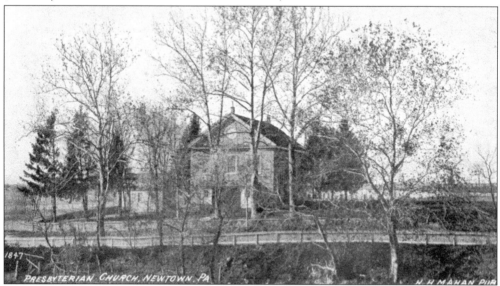

In image: 1847 PRESBYTERIAN CHURCH, NEWTOWN, PA H. H. MAHAN PUB

THE OLD PRESBYTERIAN CHURCH, C. 1900. The church building was erected on Sycamore Street in 1769 to replace the original 1734 log structure, which stood a half mile to the west. The old church was used to house prisoners during the Revolutionary War. In the graveyard, 27 soldiers of the Revolutionary War are buried. Two of them were veterans of the French and Indian War . (Courtesy of the Newtown Historic Association Inc.)

Five
EDUCATION

As late as 1830, the education of children took place either in a private school, by tutors, or by the parents themselves. But old ways of educating children at country schools in Pennsylvania were outdated and the question of adopting a public school system was debated. This concept was met with opposition, but a bill was finally passed in 1834. The act was optional with counties and townships. However, Newtown Township adopted the proposition as early as the following year. This included the town proper, as the borough had not yet been incorporated. Today, there are many schools in this community. Through the great achievements of these schools and their students, Newtown has become well known and respected.

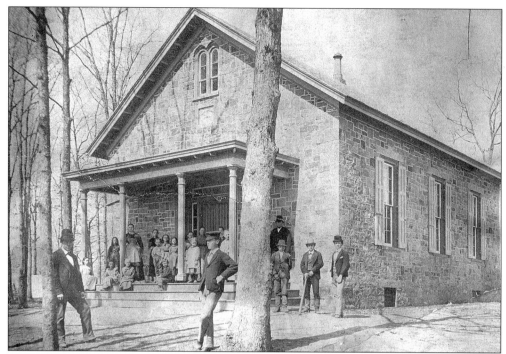

GOOD INTENT SCHOOL, C. 1885. This school was located at 100 Municipal Drive off Durham Road (Route 413) and now houses the zoning office for Newtown Township. The lot was purchased on August 21, 1843, by the Newtown Township School District for $25 from John Holcombe. The school was built in 1874. (Courtesy of the Newtown Historic Association Inc.)

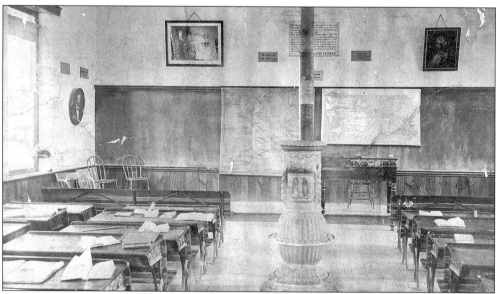

THE INTERIOR OF THE GOOD INTENT SCHOOL, C. 1900. This one-room schoolhouse measured 30 by 40 feet and was heated by the coal stove in the center. (Courtesy of the Newtown Historic Association Inc.)

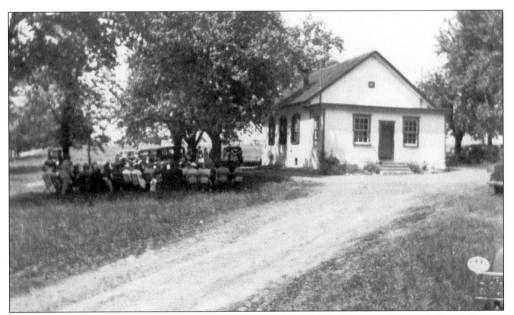

PROSPECT SCHOOL, C. 1880. This school is located at 58 Washington-Crossing Road (Route 532), about three-quarters of a mile from Newtown. The original half-acre lot was taken from the former David Harvey farm and conveyed to "the Directors of Common Schools of the Township of Newtown district," by then owners of the 68-acre farm, William and Mercy Lloyd. The original structure dates from 1843, when Ingram Krosen built it for $296.43. The school was sold on Saturday, October 14, 1939, at public sale. (Courtesy of the Newtown Historic Association Inc.)

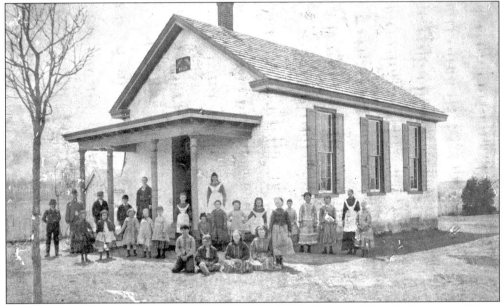

THE WEST SCHOOL, C. 1935. This school is located on the corner of the 413 Bypass and Route 332, across the street from the present Newtown Junior High School. In 1870, the original frame structure was torn down and a larger stone school was built in its place. (Courtesy of the Newtown Historic Association Inc.)

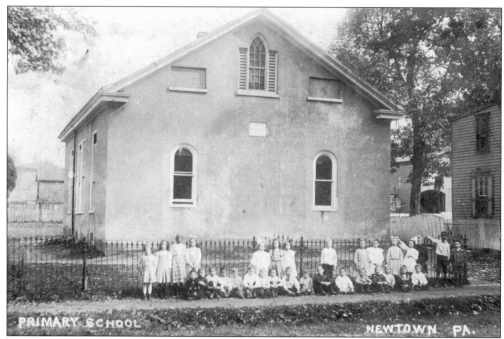

THE METHODIST EPISCOPAL CHURCH PRIMARY SCHOOL, AUGUST 7, 1918. This building is located on the corner of Liberty and Greene Streets. (Courtesy of the Newtown Historic Association Inc.)

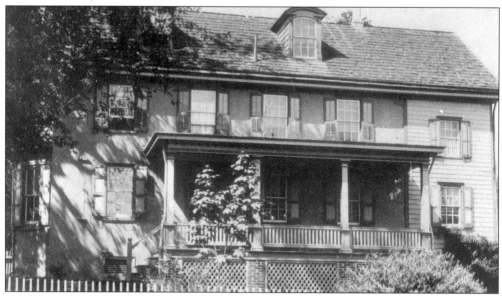

ANN BUCKMAN'S SELECT SCHOOL FOR GIRLS, C. 1890. Located at 201 Penn Street on the northeast corner of Penn and Congress Streets, this school was founded in the early 1830s. An advertisement in the *Bucks County Intelligencer* reads, "Ann Buckman still continues her Boarding School for Girls in the village of Newtown, Bucks County. Thankful for past favors, she hopes to merit a continuance of the same. Terms: For Board and Tuition, 23 dollars per quarter, payable in advance. Washing 25 cents per dozen. Stationery furnished at moderate prices." (Courtesy of the Newtown Historic Association Inc.)

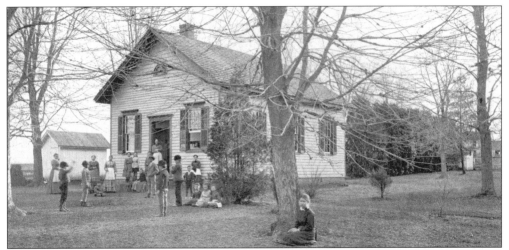

THE SILVER LAKE SCHOOL, C. 1875. This school was located near Silver Lake on Newtown-Yardley Road, about a mile east of Newtown. The lake was originally known as Janney's Dam and the schoolboys called the school "that Dam School." Having heard this expression too often, the first teacher, Mrs. Thomas, reportedly looked at the sun shimmering on the lake and remarked that the lake looked as if it were liquid silver. From that day on, both the school and the lake were called Silver Lake. The Newtown School District offered this building for public sale on October 14, 1939, at the same time as the Prospect Hill School. (Courtesy of the Newtown Historic Association Inc.)

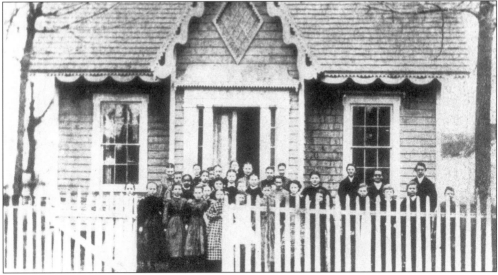

THE NEWTOWN COTTAGE SCHOOL, MARCH 20, 1868. This school, located at 15 Liberty Street across from the firehouse, was built in 1853. By that time, the town's population had grown so much that the Yellow School, which was located at State and Court Streets opposite the Quaker Meetinghouse (see page 43), could no longer house the children. Huldah Price taught the boys at the Yellow School and Rachael Bond taught the girls at this school. However, when County Superintendent William Johnson visited the borough in 1857, his biggest criticism regarded the segregation of the students by sex rather than by academic progress. The schools were subsequently graded. The Yellow School became the Primary School and the Cottage School became the grammar school. (Courtesy of the Newtown Historic Association Inc.)

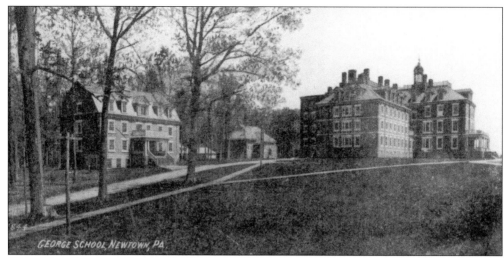

"OLD MAIN" AT THE GEORGE SCHOOL, C. 1920. The site of the school, originally the Worth Farm and the Sharon Amusement Park, was purchased in 1891 with donations from Newtown area Quakers and a bequest from John M. George. The 220 acres impressed selection committee members, including Isaac Eyre of Newtown because of its proximity to Newtown and the convenience of the Reading Railroad for transporting people and supplies. (Courtesy of the Newtown Historic Association Inc.)

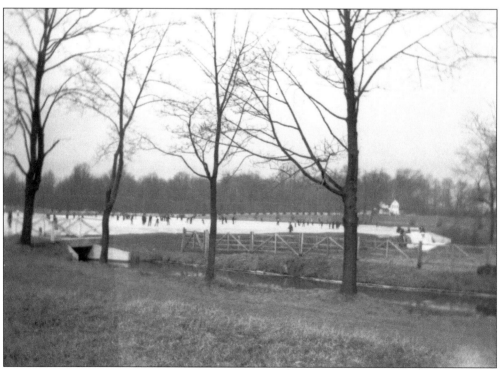

SKATING ON THE GEORGE SCHOOL POND, C. 1920. (Courtesy of the Newtown Historic Association Inc.)

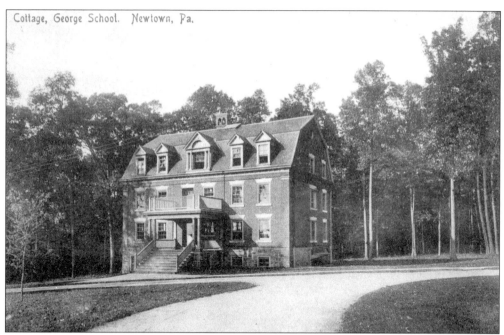

Cottage, George School. Newtown, Pa.

GEORGE SCHOOL COTTAGE, C. 1915. The unexpectedly large enrollment at the opening of the school made the construction of a second dormitory building imperative. Commonly called "the Cottage," Hallowell Hall (its first name) was built in 1894 to house the younger boys. Its name was chosen in memory of the distinguished Quaker teacher Benjamin Hallowell, but it was renamed Orton Hall in 1904. (Courtesy of the Newtown Historic Association Inc.)

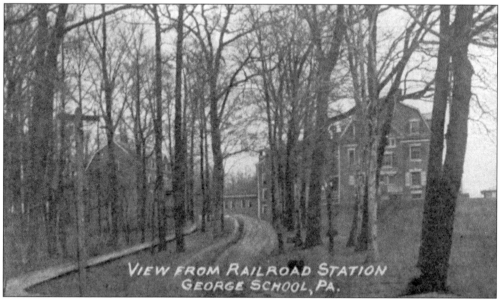

VIEW FROM RAILROAD STATION
GEORGE SCHOOL, PA.

THE GEORGE SCHOOL RAILROAD STATION, DECEMBER 20, 1910. The story is told by a graduate that a group of boys took a large quantity of grease from the kitchen and applied it to the railroad tracks at the George School Station. Later that day, when the 5:30 P.M. train from Philadelphia arrived it slid halfway to Newtown. (Courtesy of the Newtown Historic Association Inc.)

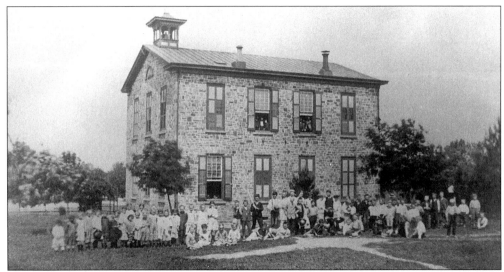

NEWTOWN PUBLIC SCHOOL (CHANCELLOR STREET SCHOOL), C. 1885. This school was dedicated on May 1, 1872, and closed in June 2000. A clip from the *Newtown Enterprise*, March 16, 1871, reads, "The School Directors of Newtown borough have decided to erect a schoolhouse on the lot purchased of Samuel Phillips, on Congress Street. It will be 60 x 36 feet, two stories high, and is intended to accommodate 235 pupils, in two schools. The first Principal was Helen R. Marshall who received $65 per month salary. One teacher drew $35 per month and the janitor was paid $10 per month." (Courtesy of the Newtown Historic Association Inc.)

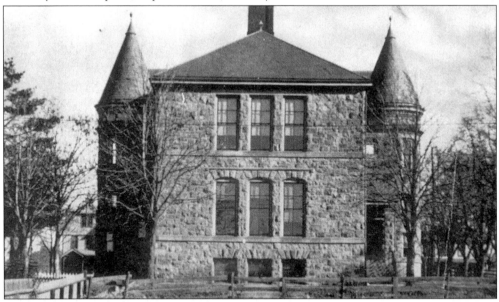

NEWTOWN HIGH SCHOOL (CHANCELLOR STREET SCHOOL), C. 1925. A fire on the morning of June 2, 1916, caused severe damage to the structure. The fire began in the basement and spread from the incinerator-type arrangement through the ventilation flues to the upper part of the building. The upper floor was greatly damaged, and some of the roof on the east end fell in. Fortunately, since the term had ended the day before, there were few people in the school at the start of the fire. Reconstruction and the large front addition were completed in 1918. (Courtesy of the Newtown Historic Association Inc.)

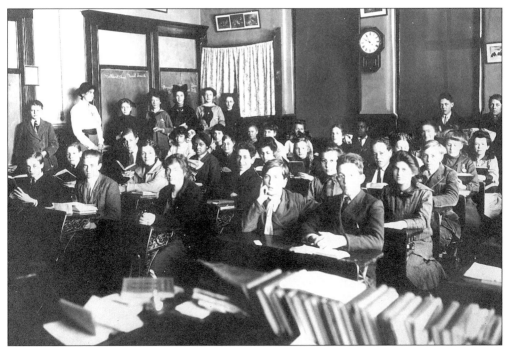

CHANCELLOR STREET SCHOOL. Some students from the 1913–1914 seventh-grade class of Miss Swift are Helen Scott, Leon Milnor, Phyllis Trexler, Minnie Tomlinson, Lenor Sheer, Harold Sutton, Myrtle Tictzen, Kathleen Schneck, ? Schuman, Louise Dederer, Helen Arnwine, Helen Dyer, Lillian Gourley, Miriam Reeder, and ? Smith. (Courtesy of the Newtown Historic Association Inc.)

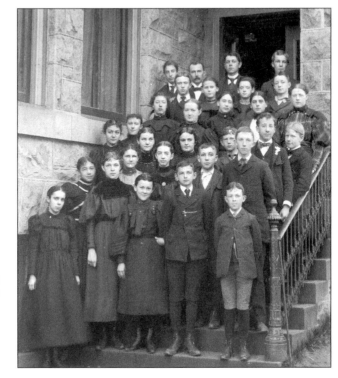

STUDENTS FROM THE CHANCELLOR STREET SCHOOL. When this class photograph was taken in 1890, the principal of the school was Mr. Walter (with mustache in back). This photograph was taken by Willie Randall. (Courtesy of the Newtown Historic Association Inc.)

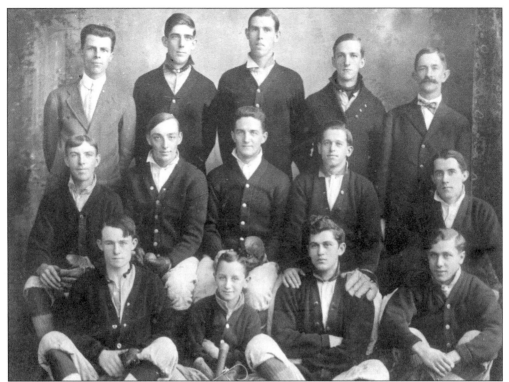

NEWTOWN HIGH SCHOOL BASEBALL TEAM, C. 1910. The team members shown are John Rempfer, John McCarty, Charles Rempher, Clinton Smith, Albert Girton, Charles Urban, Bob Finney, Alfred Burns, Frank Bye, Francis Burns, Earl Hutchinson, James Burns, Bob Dafter, and Earl Scott. (Courtesy of the Newtown Historic Association Inc.)

NEWTOWN HIGH SCHOOL CLASS, C. 1917. After the fire (see page 80), classes were held at the Township House building from 1916 to 1918. During the first school year after the fire, 1916–1917, eighth grade and high school classes were held at the Wentworth Building (Township House), located on the corner of Sycamore and Jefferson Streets. (Courtesy of the Newtown Historic Association Inc.)

Six

AGRICULTURE

At the beginning of the 19th century, Newtown was an active and affluent commercial center, supporting tradesmen and artisans in all of the traditional occupations. Demand for Newtown's products and services steadily increased during this period, as Newtown became more widely known throughout the region. As the century progressed, the community remained a busy commercial and cultural center for the surrounding farms. After the county seat was relocated from Newtown to Doylestown in 1813, Newtown was gradually transformed into the tranquil farming community it had once been. In addition to the many historic homes and businesses that line the streets today, one can still sense the industrial and agricultural activity that thrived here centuries ago.

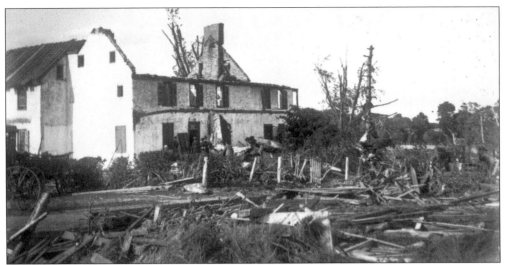

THE BUCKMAN HOUSE AND BARN, AFTER THE CYCLONE OF 1896. The Buckman house was built in 1708 on Fulling Mill Road bordering Newtown Township. An article from the Saturday, June 6, 1896 edition of the *Newtown Enterprise* described the aftermath of a terrible cyclone, "At John B. Buckman's, near Langhorne, in Middletown Township, the ruin wrought by the fierce tornado was more complete that at any other place in Bucks County. The main part of the house was unroofed and one gable was blown out. All the trees about the buildings were either uprooted or twisted off and were thrown in different directions. Trees, stone walls, boards, building timber, etc. are lying about in the greatest confusion." (Courtesy of the Newtown Historic Association Inc.)

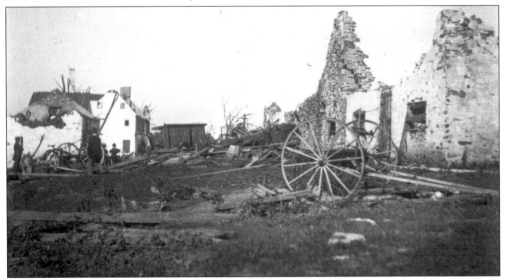

THE BUCKMAN PROPERTY, AFTER THE CYCLONE OF 1896. The *Newtown Enterprise* article continues, "The large buildings on the farm, which contains about 145 acres, are a mass ruins. The only structure that is not wrecked is a springhouse in the meadow across the road from the rest of the buildings. Everything at this place was built of stone in the substantial manner of long ago. The barn and all outbuildings, with the exception of a part of the walls of the wagon house, are down. A scene of unparalleled desolation is presented to the eye at this place." (Courtesy of the Newtown Historic Association Inc.)

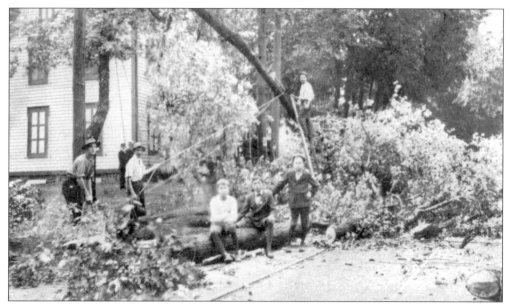

WASHINGTON AVENUE, AFTER THE STORM OF AUGUST 7, 1908. The *Newtown Enterprise* reported on August 15, 1908, "Not for 40 years had Newtown been in the grasp of such a storm as raged here for a few minutes shortly after 1:00 p.m. last Friday afternoon. North State Street received the full force of the storm, however, as seen in this photograph, the wind caused nearly as much destruction at E.S. Hutchinson's corner, Washington Avenue and Congress Street." (Photograph by Thompson Roberts, courtesy of the Newtown Historic Association Inc.)

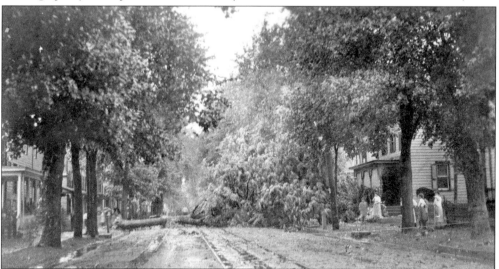

NORTH STATE STREET, AFTER THE STORM OF AUGUST 7, 1908. The *Newtown Enterprise* article continues, "North State Street received the full force of the storm and there were three trees were thrown across the street. A big maple in front of Calvin Tomlinson's, a large Mahogany tree, one of the landmarks of the town, in front of Jacob T. Lovett's, and a Maple in front of W.H. Longshore's. The mahogany tree is a native in tropical America, but seems able to withstand our northern winters. The wood is reddish brown, beautifully veined, very hard and susceptible of a fine polish." (Photograph by Thompson Roberts, courtesy of the Newtown Historic Association Inc.)

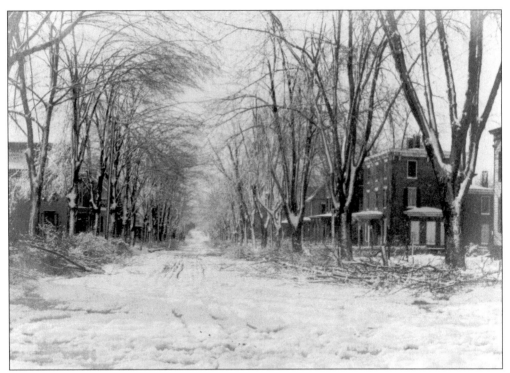

WASHINGTON AVENUE, LOOKING SOUTH TOWARD CHANCELLOR STREET, FEBRUARY 4, 1899. The *Newtown Enterprise* of February 10, 1899, reads, "There have been three snowstorms, the first beginning early on Sunday morning and lasting about all day; the second started late Monday afternoon and kept up all the following night, and the last began Tuesday afternoon, continuing all night and well into Wednesday. The total fall has been in the neighborhood of nine inches." (Courtesy of the Newtown Historic Association Inc.)

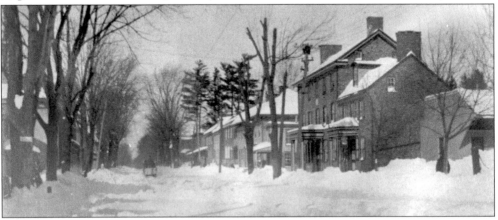

SOUTH STATE STREET, LOOKING NORTH TOWARD WASHINGTON AVENUE, FEBRUARY 4, 1899. The *Newtown Enterprise* continues, "Thursday morning the temperature was anywhere from zero to fourteen degrees below that point, according to location and kind of thermometer. Seldom indeed is such a frigid February day experienced in Bucks County. Country roads were somewhat drifted, but the sleighing was reported first-class, the best for a long time, the only drawback to its enjoyment by devotees of the sport being the extreme cold." (Courtesy of the Newtown Historic Association Inc.)

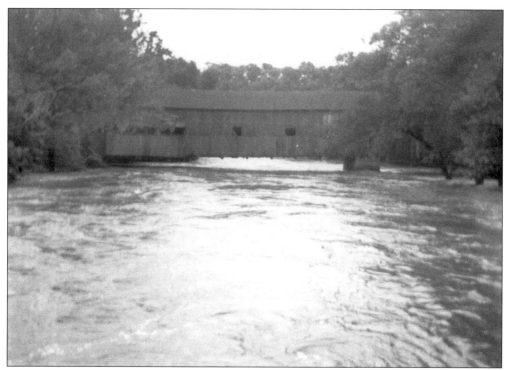

THE SCHOFIELD FORD BRIDGE (THE TWINING FORD BRIDGE), 1887. This bridge spanned the Neshaminy Creek for over 100 years until its senseless demise in 1991 at the hands of an arsonist. Through a countywide volunteer effort in 1991, this historically significant structure was lovingly rebuilt. (Courtesy of the Newtown Historic Association Inc.)

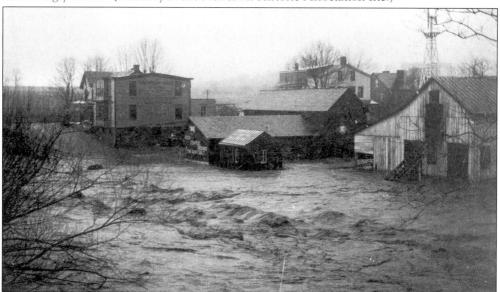

THE JEFFERSON STREET BRIDGE, 1903. This photograph was taken during the flood of 1903 from the roof of the J.V. and C. Randall Carriage works on North State Street. The building to the left is the Township House and the buildings to the right are the old carriage storage barns for the carriage works. (Courtesy of the Newtown Historic Association Inc.)

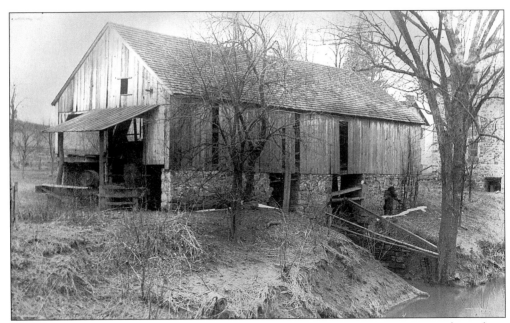

SPRING GARDEN SAWMILL, C. 1912. This mill is located in Newtown Township where Newtown-Richboro Road crosses the Neshaminy. The photograph shows the old frame building that was located just south of Spring Garden Mill. This building originally housed a sawmill but was converted into a cider mill in 1910. The power for the latter still came from the 10-horsepower water turbine. (Courtesy of the Newtown Historic Association Inc.)

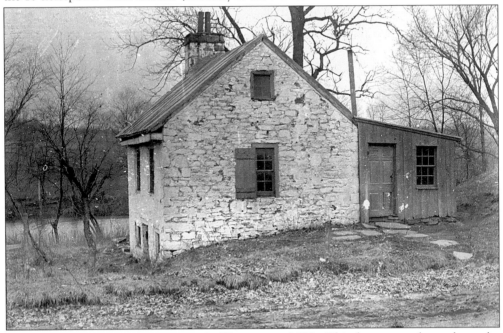

SPRING GARDEN MILL TOLLKEEPER'S HOUSE, C. 1890. This house was located on the Newtown side of the creek where the old covered bridge crossed the Neshaminy on Newtown-Richboro Road. This stone structure, probably the home for the tollkeeper, was razed in the 1960s. (Courtesy of the Newtown Historic Association Inc.)

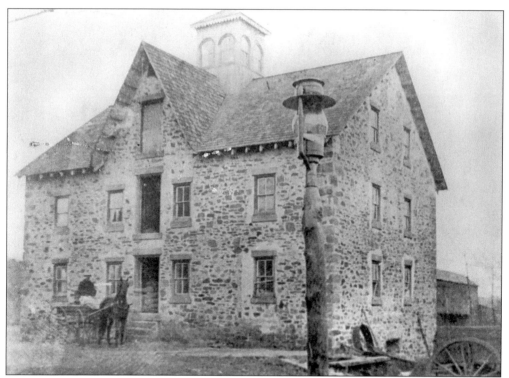

SPRING GARDEN MILL, C. 1892. This mill, built in 1819, was known as a feed mill. It burned in 1875 and was rebuilt in 1878. (Courtesy of the Newtown Historic Association Inc.)

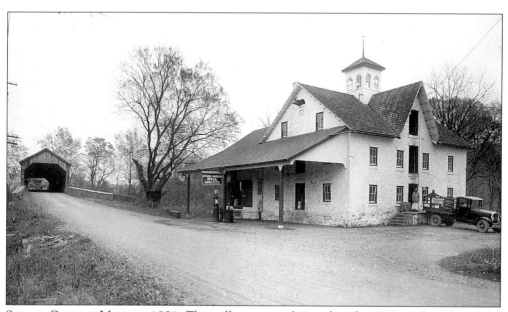

SPRING GARDEN MILL, C. 1931. The mill was reconditioned in the 1920s and, in the 1960s, was converted into a playhouse. Note the covered bridge in the background, which was washed out during the disastrous flood of 1955. A new bridge was built in the 1930s when the road was rerouted. (Courtesy of the Newtown Historic Association Inc.)

"EASTER BOY", C. 1915. This horse was owned and driven by Harry Leedom, proprietor of the Temperance House. The photograph was taken by Willie Randall at the White Hall Stables, located at 127 South State Street. (Courtesy of the Newtown Historic Association Inc.)

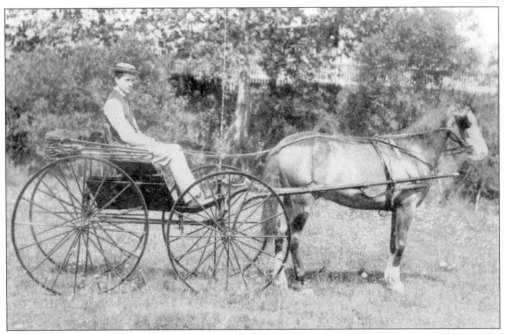

A NEW PHAETON BUGGY FROM THE RANDALL CARRIAGE WORKS, C. 1895. According to the Randall catalog, "this comfortable carriage is easy to get into because it sets low, with a high spring back. It features cloth cushions, a leather top, and a finely painted body." (Courtesy of the Newtown Historic Association Inc.)

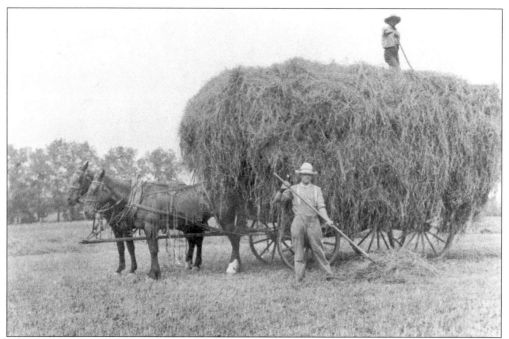

RAKING HAY ON LEDGE SPRING FARM, C. 1925. George Gore, owner of Ledge Spring Farm, stands in front of his hay wagon, with Edwin Thatcher atop the wagon. Ledge Spring Farm was located on Swamp Road in Newtown Township where the Tyler Walk development now stands. The farmhouse and buildings were razed in the 1970s. (Courtesy of Brian E. Rounsavill, Newtown, Pennsylvania.)

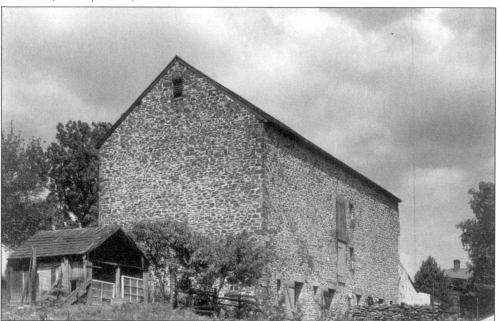

JOE HARVEY'S BARN, C. 1940. This barn is located at 480 Washington-Crossing Road in Newtown Township, near the intersection of Linton Hill Road. (Courtesy of the Newtown Historic Association Inc.)

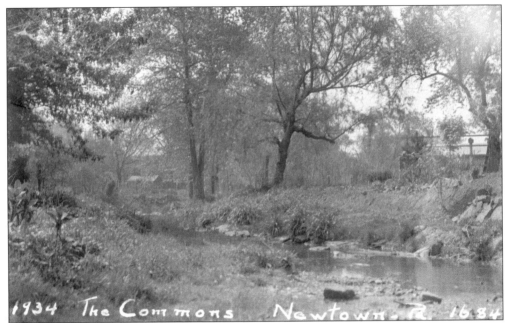

NEWTOWN COMMONS, 1934. A stone monument was erected at the 250th anniversary of Newtown in 1934 by Anna Smith. Located behind the property at 100 North State Street, the monument marks the last remaining parcel of the Newtown Common. The common once provided public access to the land bordering the Newtown Creek and was also a focal point for many daily activities. (Courtesy of the Newtown Historic Association Inc.)

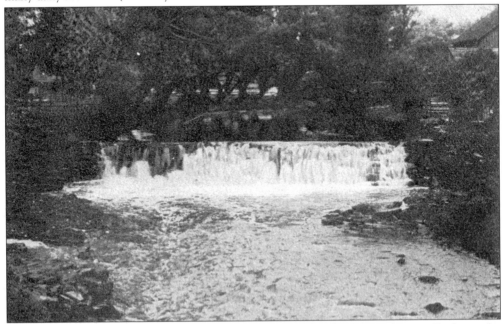

NEWTOWN CREEK, C. 1910. This view looks up stream from the Centre Avenue Bridge at the ancient milldam. Water flowing along the millrace on the right side was sufficient to turn the overshot waterwheel at the Cologne Gristmill, located just over a half mile downstream at the Barclay Street Ford over Newtown Creek. (Courtesy of the Newtown Historic Association Inc.)

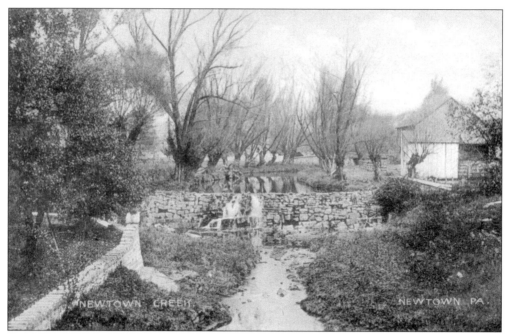

NEWTOWN CREEK, JANUARY 18, 1909. This is another view looking up stream from the Centre Avenue Bridge. This bridge was built in 1796 and is the second oldest stone arched bridge in Pennsylvania. (Courtesy of the Newtown Historic Association Inc.)

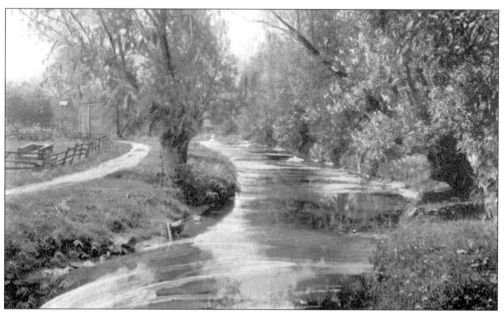

NEWTOWN CREEK, JUNE 20, 1917. This shot was taken from just south of Jefferson Street, which at the time was called Church Street. (Courtesy of the Newtown Historic Association Inc.)

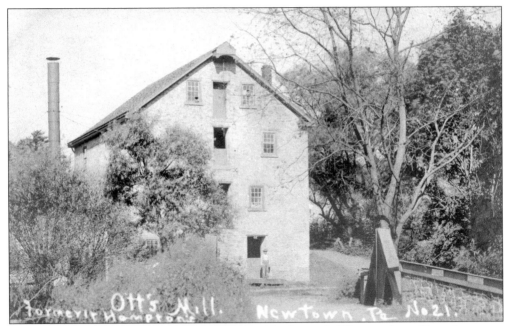

BARCLAY STREET GRISTMILL, C. 1890. Operated by James A. Ellinger, the mill was known as Ott's Mill and later the Cologne Mill. This building was completed in 1831 at 10 Barclay Street on the borough side of the Newtown Creek. (Courtesy of the Newtown Historic Association Inc.)

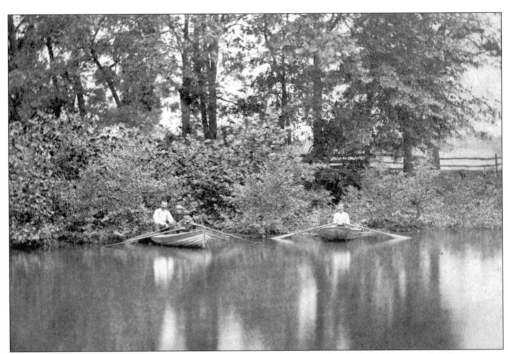

BOATING ON THE NESHAMINY, C. 1877. This photograph was taken at the mouth of Newtown Creek. Mac Buckman is in the boat alone at the right. Will Church, Roger Williams, and Willie Smith are in the other boat. (Courtesy of the Newtown Historic Association Inc.)

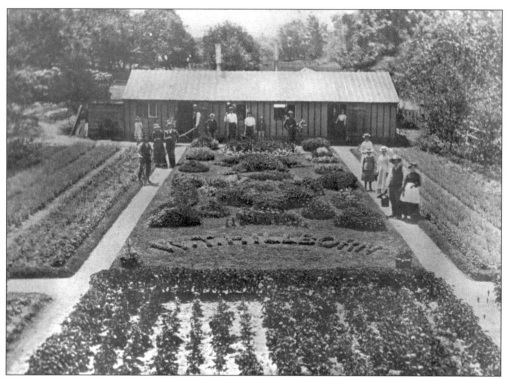

WATSON T. HILLBORN'S GREENHOUSE, C. 1900. This photograph shows the Hillborn's greenhouse as seen from West Centre Avenue. Today, this is the site of the municipal parking lot at 10 West Centre Avenue. (Courtesy of the Newtown Historic Association Inc.)

WATSON T. HILLBORN NURSERIES, C. 1900. This view is from atop the Newtown Hardware House (106–108 South State Street), looking west toward the intersection of Sycamore Street and Centre Avenue. The McMasters House is located in the top right of the photograph, at 19 West Centre Avenue. (Courtesy of the Newtown Historic Association Inc.)

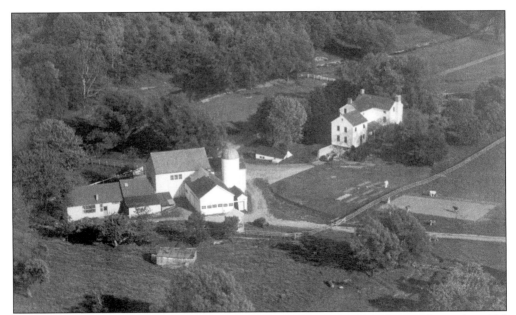

AN AERIAL VIEW OF THE DR. JOHN PREECE FARM, 1941. This farm is located at 398 Washington-Crossing Road on the East Side of Route 532. John Preece came from North Dakota and was an obstetrician at Mercer Hospital in Trenton, New Jersey. His hobby was breeding and racing thoroughbred horses at the racetracks in the tri-state area. (Photograph by Walter Lefferts, courtesy of the Newtown Historic Association Inc.)

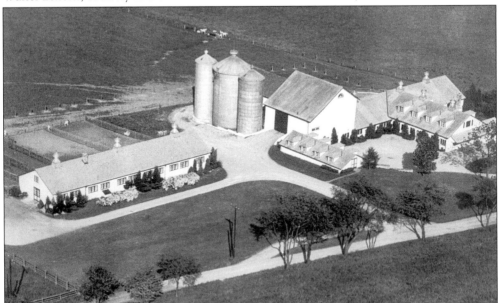

AN AERIAL VIEW OF NESHAMINY FARMS, 1941. This dairy farm was located on the Tyler Estate, which spans Newtown and Northampton Townships and which is now Tyler State Park. The farm raised Ayrshire cattle and supplied milk to the Tyler Estate as well as other locals. Tyler State Park was established in the 1960s and the dairy farm buildings were razed in the 1980s, but the cement flooring slabs are still visible today. (Photograph by Walter Lefferts, courtesy of the Newtown Historic Association Inc.)

Seven

ORGANIZATIONS
AND RECREATION

Newtown experienced significant growth and an influx of inhabitants when the county seat moved from Bristol to Newtown in 1725. As a result, many organizations, clubs, events, and amusements became commonplace. Minstrel shows, medicine shows, circuses, menageries, sideshows, and exhibitions all came to town to entertain and amuse the Newtown locals in the 1800s. One of the early sideshows was the United Brothers of Chang-Eng, the original Siamese twins. The *Bucks County Intelligencer* of July 12, 1859, reports, "The people of Newtown celebrated the Fourth of July by a torchlight procession and a grand display of fireworks on Monday evening. A stand was erected in the wide street, on the west side of the exhibition ground, from which, in the presence of a large collection of people, large quantities of rockets, Roman candles, pin wheels, and numerous other things of odd shapes and dazzling beauty were set off to the excessive gratification of the spectators. The occasion was enlivened by first-rate music from a homemade band. At the close of the powder-burning entertainment, Capt. Joseph Eyre delivered an exceedingly neat and patriotic address, which was received with rapturous applause. The crowd then quietly dispersed, and many proceeded to the saloon of Mr. Rose where they cooled off their patriotism by eating not less than a hogshead of ice cream—so we are assured. A few patronized other establishments, and kept alive till a late hour, a strong patriotic passion by frequent potations of fire water."

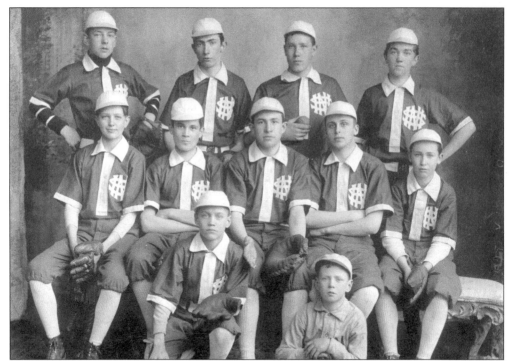

THE NEWTOWN HIGH SCHOOL BASEBALL TEAM, APRIL 19, 1912. This photograph was taken before a game against the George School. Team members are, from left to right, as follows: (front row) H. Burns and L. Hennessy; (middle row) F. Hutchinson, E. Kurst, R. Rook, S. Watson, and E. DeCoursey; (back row) C.H. Twining, R.C. Smith, W. Jamison, and L. Duckworth. Uniforms cost approximately $4, and each player furnished his own. Shoes were optional. (Courtesy of the Newtown Historic Association Inc.)

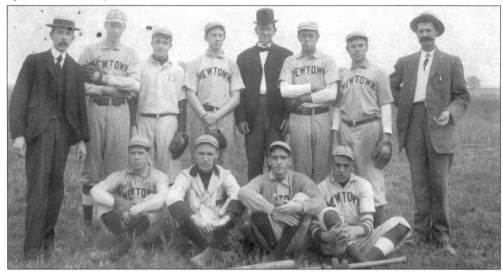

NEWTOWN HIGH SCHOOL BASEBALL TEAM, 1908–1909. Shown from left to right are the following: (front row) H. Hilborn, ? Kelly, P. Bush, and unidentified; (back row) G. Walker, three unidentified players, B. Hutchinson, A. Taylor, unidentified, and E. Gourley. (Courtesy of the Newtown Historic Association Inc.)

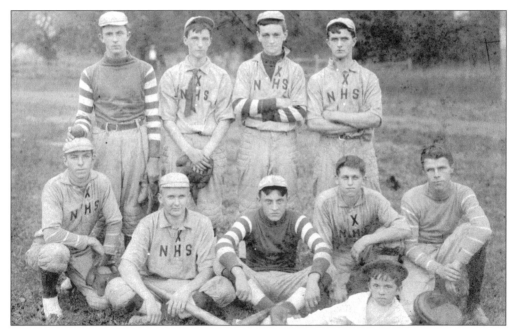

THE NEWTOWN HIGH SCHOOL BASEBALL TEAM, C. 1915. Team members are, from left to right, as follows: (front row) Charles Urban, John Bryan, John Tranter, Frank Bye, John Rempher, and unidentified; (back row) unidentified, Chuck ?, Alfred Crewitt, and Frank Sutton. (Courtesy of the Newtown Historic Association Inc.)

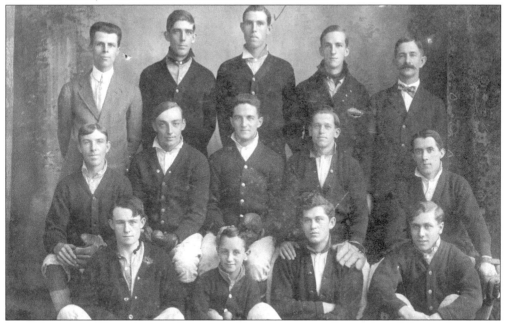

THE NEWTOWN HIGH SCHOOL BASEBALL TEAM, C. 1910. Shown from left to right are the following: (front row) Earl Hutchinson, James "Easy" Burns, Bob Dafter, and Earl "Gummy" Scott; (middle row) Charles "Dutch" Urban, Bob Finney, Alfred Burns, Frank Bye, and Francis Burns; (back row) John Rempfer, John McCarty, Charles Rempfer, Clinton Smith, and Albert Girton. (Courtesy of the Newtown Historic Association Inc.)

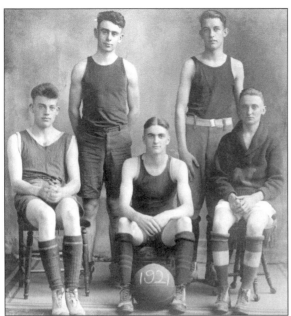

THE NEWTOWN HIGH SCHOOL
BASKETBALL TEAM, 1921. These
players are, from left to right,
Bentley Canby, Jim Dougherty, Ken
Davis, John McCue, and Leo Tyrell.
(Courtesy of the Newtown Historic
Association Inc.)

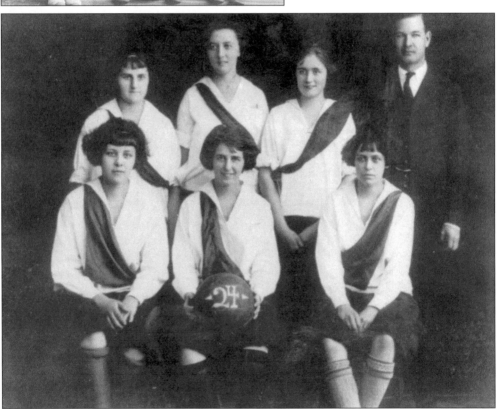

THE NEWTOWN HIGH SCHOOL GIRLS BASKETBALL TEAM, 1924. Shown from left to right are
the following: (front row) Grace Albright, Aura Grace, and Libby Hutchinson; (back row)
Edith Buckman, Anna Hennessy, Marie Kelly, and Newil B. Ward (teacher-coach). (Courtesy
of the Newtown Historic Association Inc.)

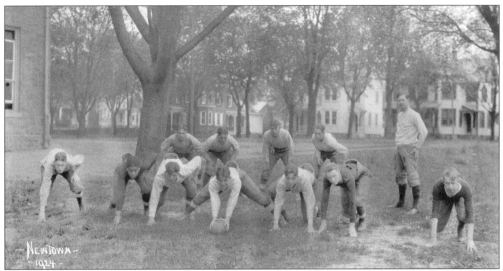

NEWTOWN HIGH SCHOOL FOOTBALL TEAM, 1924. Posing on the side lot of the Newtown High School on Chancellor Street are, from left to right, the following: (front row) William Suber, Martin Powell, Wayne Flagg, John Bone, Ed Seese, Harvey Riddle, and Charles Gordon; (back row) Frank Fabian, Alfred Lownes, Ardel Clark, Wilmer Lownes, and Coach Ward. (Courtesy of the Newtown Historic Association Inc.)

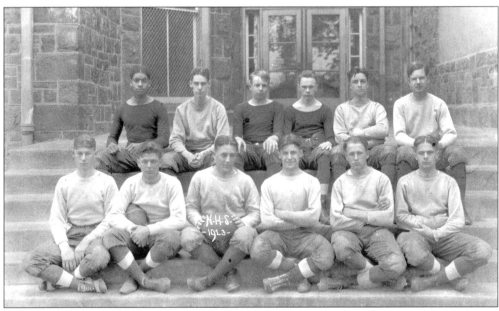

NEWTOWN HIGH SCHOOL FOOTBALL TEAM, 1923. Shown on the side steps of the Newtown High School are, from left to right, the following: (front row) Ardel Clark, Wayne Flagg, Alfred Lownes, John Bone, Wilmer Lownes, and Frank Fabian; (back row) Martin Powell, William Suber, Charles Gordon, Harvey Riddle, Ed Seese, and Coach Ward. (Courtesy of the Newtown Historic Association Inc.)

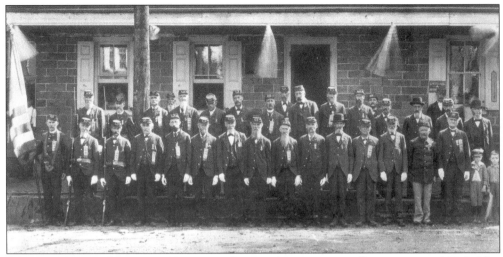

THE T.H. WYNKOOP POST, NO. 427, GRAND ARMY OF THE REPUBLIC, C. 1896. This photograph was taken following a parade of the post, possibly on Memorial Day. The post then had about 50 members, although only 32 are pictured here. In 1896, the Newtown Borough Council appropriated $23.50 to help defray the expenses of the parade. The small boy at bottom right (holding the hand of Franklin Cornell and next to J. Aubrey Crewitt) is Morell Smith. Smith was later killed in World War I. The Morell Smith Post, No. 440, American Legion was named in his honor. (Courtesy of the Newtown Historic Association Inc.)

TWO TINTYPES OF THE NEWTOWN CORNET BAND, C. 1880. Leonard Fuhrer, John Phillips, and William Phillips pose in the left photograph. In the photograph on the right are Leonard Fuhrer, James Voorhees, William Phillips, and John Phillips. (Courtesy of the Newtown Historic Association Inc.)

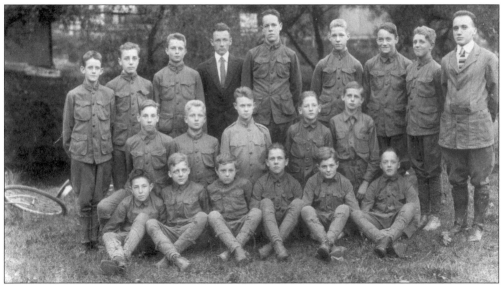

BOY SCOUT TROOP, 1915. Shown from left to right are the following: (front row) unidentified, Lou Wettling, Bob Burns, Clifton Texler, unidentified, and Edward Elliot; (middle row) George Keller, George Bone, unidentified, Bill Feaster, and Dave Watson; (back row) unidentified, Lewis Fitzgerald, Ben Burns, unidentified, Harold Sutton, Clarence Savidge, Williard Schuster, Bill Fretz, and ? Reese. (Courtesy of the Newtown Historic Association Inc.)

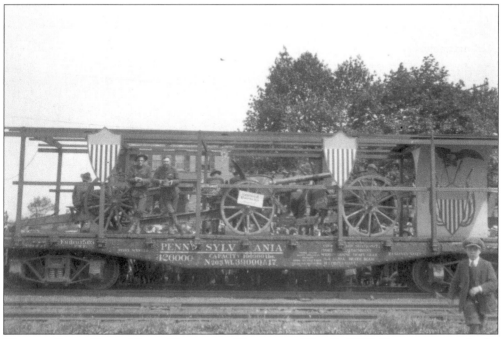

VICTORY LOAN TRAIN VISITS NEWTOWN, THURSDAY, MAY 8, 1919. Seven cars were in the train. Three platform cars were loaded with cannons captured from the Germans, including two large tanks. The other cars were an enclosed exhibit car, two passenger cars, and one dining car. (Courtesy of the Newtown Historic Association Inc.)

NEWTOWN CENTURY CLUB MEMBERS QUILTING, C. 1920. Pictured are Helen Fretz, Sarah Packer, Adele Darrah, Beulah Mohr, Emily Walton, Elizabeth Case, Heila Kenderdine, and Mary T. Hillborn. The New Century Club was organized in November 1895 by a group of women from this area, with the help of two members of the New Century Club of Willmington, Delaware. The latter club was formed eight years earlier. Anna M. Maris was the first president of the Newtown Club. (Courtesy of the Newtown Historic Association Inc.)

WOMEN'S CHRISTIAN TEMPERANCE UNION (WCTU) MEETING, C. 1915. This meeting took place on the meadow, which was located at 109 South Chancellor Street. In the fall of 1873, women concerned about the destructive power of alcohol met in churches to pray and then marched to the saloons to ask the owners to close their establishments. The WCTU of Newtown, auxiliary to the WCTU of Pennsylvania, was organized by Emily Underhill, of Westchester County, New York, in 1885. The first regular meeting was held in the lecture room of the Presbyterian church on Centre Avenue. (Courtesy of the Newtown Historic Association Inc.)

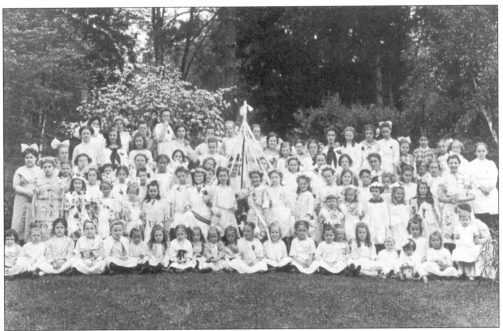

MAY DAY CELEBRATION, 1911. This celebration took place on the lawn of Dr. Heston's property at 212 South State Street. (Courtesy of the Newtown Historic Association Inc.)

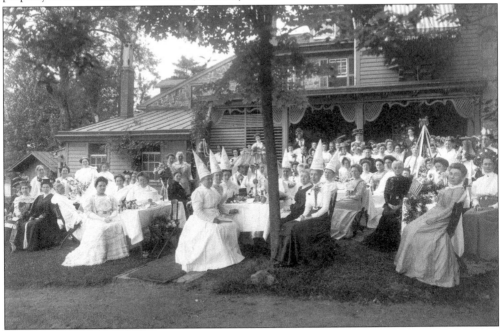

NEWTOWN NEW CENTURY CLUB "CALENDAR PARTY," c. 1900. The Calendar Party was organized to close out the club year. It consisted of 12 tables set up to represent the 12 months of the year. The ladies wore pointed hats and celebrated birthdays during the month of this gathering. According to an article in the *Newtown Enterprise*, "the scene was truly beautiful, amusing and original, for many of the members were costumed, which further added to the effect." (Courtesy of the Newtown Historic Association Inc.)

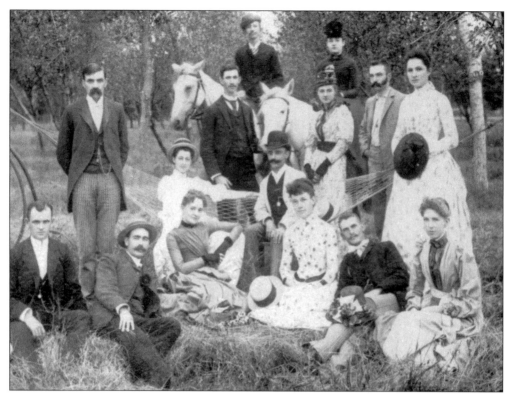

THE NEWTOWN SOCIAL ACQUAINTANCES, C. 1890. A group of local acquaintances enjoys a day in the countryside. Note the high-wheeler bicycle at left in the background. (Courtesy of the Newtown Historic Association Inc.)

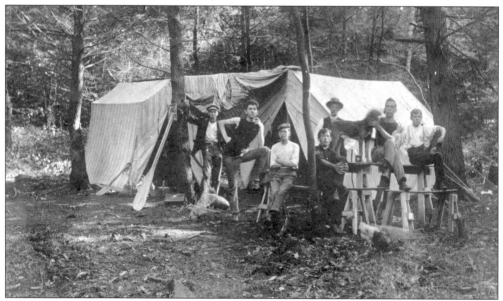

THE NEWTOWN CAMPING CLUB, C. 1910. It is believed that this photograph of the Newtown Camping Club was taken on a canoe trip up the Delaware River. (Courtesy of the Newtown Historic Association Inc.)

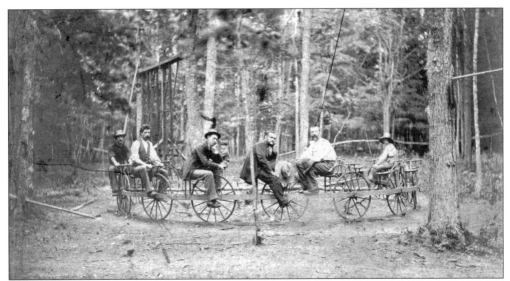

SHARON PARK, C. 1880. This amusement park was located on what is now the George School property. Sharon Park was a very early amusement park in the Newtown area. For a brief period, 1878–1884, the meadows on either side of Newtown Creek near its mouth were the site of Sharon Park. It was a place for warm-weather family outings and was serviced by the new Philadelphia, Newtown, and New York Railroad. At its height, it attracted trainloads of picnickers from Philadelphia. Its main attractions were boating and swimming in the Neshaminy, but there was also a baseball diamond, a bandstand, and a dance pavilion. The depression of the early 1880s doomed the park to a short life. Its assets were sold to pay off its debts in 1885. (Courtesy of the Newtown Historic Association Inc.)

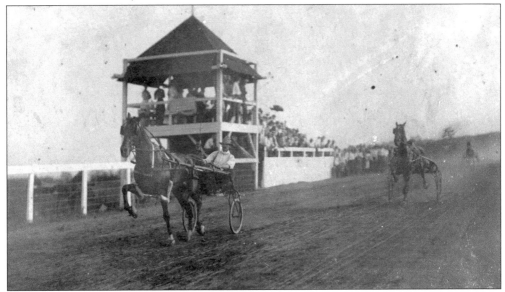

THE GRAND VIEW DRIVING PARK OF MAHLON B. FRETZ, 1914. This park was located in Newtown Township near the present intersection of the 413 Bypass and Route 332. The cars in the photograph are "Freemason" (owned by George R. Doan of Woodside, winner), "Fountain King" (owned by William P. Hicks of Fountain Farm in Newtown, placing), and "J. Stanley Lee" (up). (Courtesy of the Newtown Historic Association Inc.)

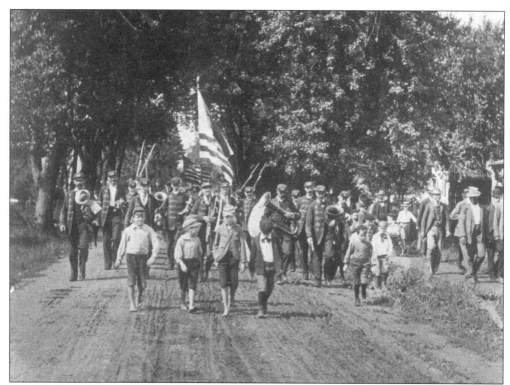

MEMORIAL DAY PARADE, C. 1900. This photograph was taken looking west on Penn Street from Lincoln Avenue. (Courtesy of the Newtown Historic Association Inc.)

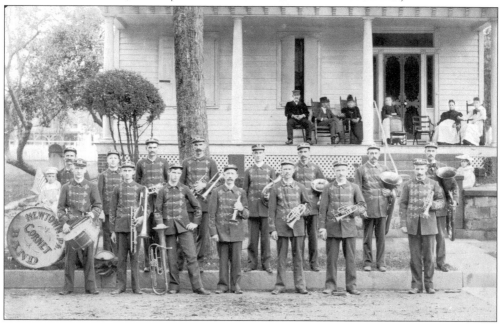

NEWTOWN CORNET BAND, C. 1895. The band poses in front of the Buckman House at 119 North State Street. The drum and cornet are still on display in the Newtown Historic Association headquarters at the Court Inn. (Courtesy of the Newtown Historic Association Inc.)

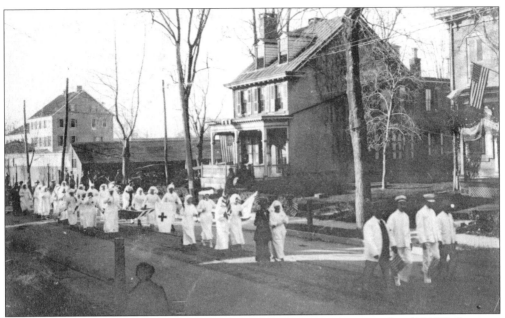

ARMISTICE PARADE, 1918. This photograph was taken across the street from 101 Washington Avenue, east of Liberty Street. Drs. Doan, Roberts, Smith, and Crewitt are in the lead. Note the Brick Hotel in the background. (Courtesy of the Newtown Historic Association Inc.)

FIREMAN'S PARADE, C. 1910. This parade is on Washington Avenue, heading west between Liberty and Congress Streets. The meat market in the background was owned by S. Scott Gray. (Courtesy of the Newtown Historic Association Inc.)

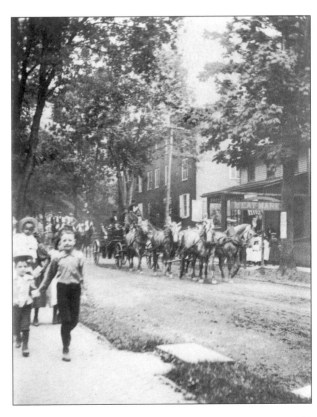

"OLD WASHY," 1920. "Old Washy" was built in 1812 by Patrick Lyon and served Newtown's three fire companies until 1897. The pumper was bought second-hand from the Washington Fire Company of Philadelphia in 1823 by Newtown's Washington Fire Company. Note the year 1796 on the pumper, which represents the year the Washington Fire Company of Philadelphia was organized, not the date that the pumper was actually built. (Courtesy of the Newtown Historic Association Inc.)

THE SECOND ENGINE HOUSE OF THE WINONA FIRE COMPANY, C. 1885. This firehouse was located at 14 Liberty Street and was razed in 1900. The first home of the Washington Fire Company, called Island No. 10, was constructed before 1831 on the North side of Centre Avenue. The new engine house, pictured at right, was erected on Liberty Street in 1871 on about the same site occupied by the present-day building. (Courtesy of the Newtown Historic Association Inc.)

NEWTOWN FIREMAN'S PARADE, 1934. This photograph was taken in front of the firehouse at 14 Liberty Street. Leading the parade is the 1924 Kearns pumper driven by W. Aubrey Merrick, with William J. Forsyth (passenger), Watson Eyre (behind bell), John Eyre (white cap), John A. Merrick (behind his father, the driver), and John Bennet (behind John A. Merrick). The Kearns pumper is followed by the 1923 Hahn. Standing in the doorway with the dark cap is William Lang. (Courtesy of the Newtown Historic Association Inc.)

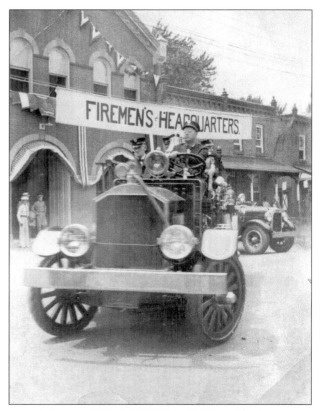

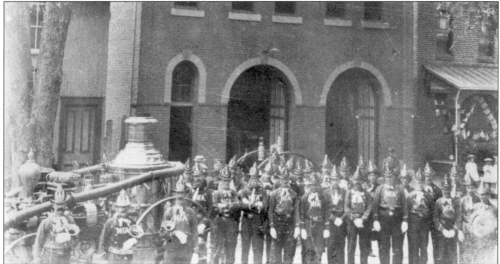

THE NEWTOWN FIRE ASSOCIATION, C. 1905. The firemen are gathered prior to a parade in front of the new firehouse for the Newtown Fire Association. On September 16, 1901, the company was incorporated under the name of the Newtown Fire Association No. 1 "for the purpose of extinguishing fires and protecting life and property." The new firehouse was erected that year, and its grand opening was on January 23, 1902. Note the Silsby steamer in the lower left, which was purchased in 1897 for $1,500 and pumped 600 gallons per minute. (Courtesy of the Newtown Historic Association Inc.)

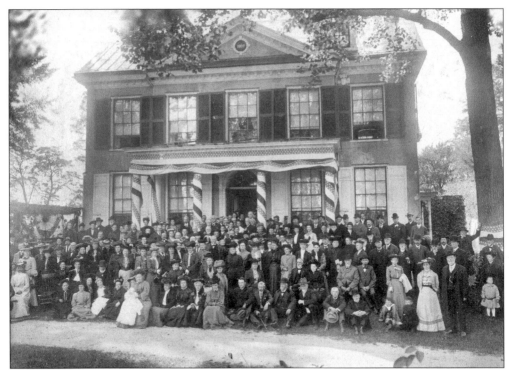

GROUP FROM THE BUCKS COUNTY HISTORICAL SOCIETY, OCTOBER 4, 1904. This photograph was taken in front of a building called Sharon, now called the Worth House, at the George School. (Courtesy of the Newtown Historic Association Inc.)

MEMORIAL DAY PARADE, 1909. Shown are two Newtown Civil War veterans, Thaddeus Kenderdine and Isaac Wright, being pulled by the team of Peter H. Morris. They are heading east on Washington Avenue, approaching the Newtown Cemetery. (Courtesy of Sarah Jane Dallas, Newtown, Pennsylvania.)

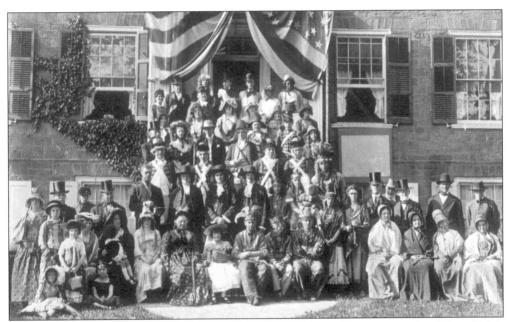

A Pageant Celebrating the 250th Anniversary of the Revolutionary War, 1934.
Those who took part in the pageant are gathered in front of the old Newtown Academy. The building was razed and this site is now the drive-in window of the First National Bank on West Centre Avenue. (Courtesy of the Newtown Historic Association Inc.)

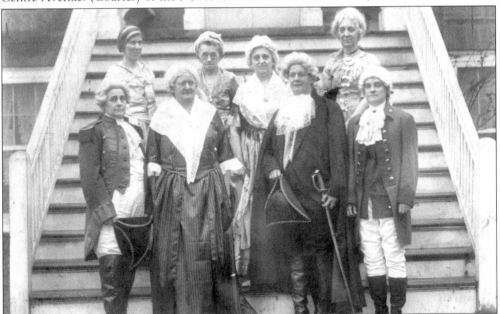

New Century Club, 1930–1931. Members of the New Century Club pose on the steps of the Newtown Academy, which was located on West Centre Avenue behind the present First National Bank and Trust Company, where the office building now stands. The club members are, from left to right, as follows: (front row) Anna Fabian, Myrtle Kester, Mary Walker, and Phyllis Wilson; (back row) Emma Woodman, Anna ?, Harriet ?, and Helen Fretz. (Courtesy of the Newtown Historic Association Inc.)

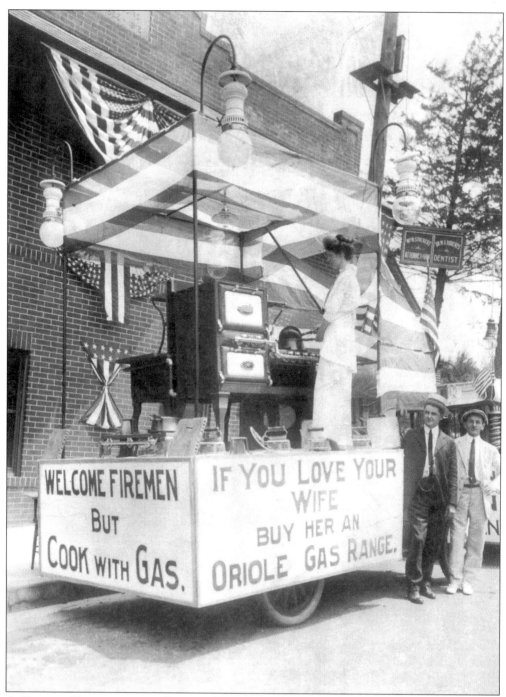

A Parade Float for the Fireman's Parade, 1915. It is believed that this float was prepared by E.C. Curry, a local gas stove promoter who wanted to establish a gas stove factory in Newtown. The float is stopped in front of the Stuckert (Hennessy) Building at the corner of Court Street and Centre Avenue. Attorney William R. Stuckert and dentist W.A. Roberts occupied the building at the time. (Courtesy of the Newtown Historic Association Inc.)

NEWTOWN FIRE ASSOCIATION, 1949. These firemen are responding to a country field fire in Newtown Township. (Courtesy of the Newtown Historic Association Inc.)

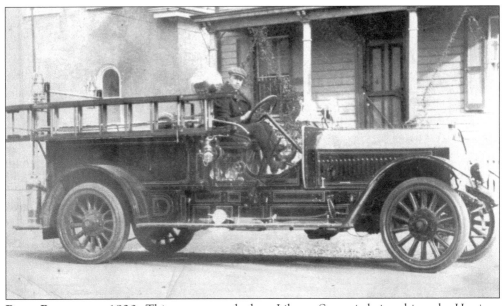

BOYD PUMPER, C. 1930. This pumper parked on Liberty Street is being driven by Harrison Ettenger. It is across from the firehouse and in front of the home just to the right of the Newtown Methodist Episcopal Church. (Courtesy of the Newtown Historic Association Inc.)

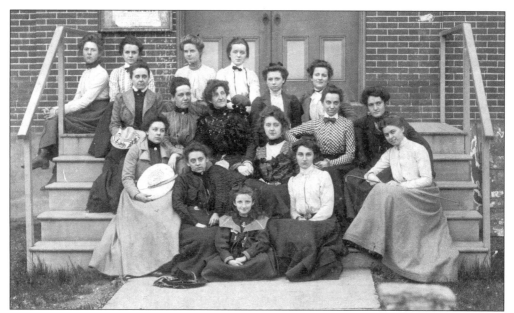

MINSTREL SHOW, MAY 1901. This show was given at Newtown Hall for the benefit of the Newtown Fire Association. Shown are Lavinia Eyre Hartley, Eleanor Worthington Twining, Helen Brown Buckman, Lillian Crewitt Cornell, Fredda Heyd Bryan, Mary Carey Linton, Mrs. Craig (leader from Kansas), Sadie Fell, Florence Sherman, Mary Scott, Marian Trego Davis, Liela Gwinner Trego, Lizzie Scott Marshall, Elizabeth Sickle Case, Alice Buckman, Alma Krewson, and Marguerita Tomlinson Terry. (Courtesy of the Newtown Historic Association Inc.)

A PLAY AT NEWTOWN HALL, C. 1900. Newtown Hall (Newtown Theatre), located at 120 North State Street, was first built in 1831 on land donated by Joseph Archambault. Originally called Free Church, the hall was where Sunday services were held until the early 1850s, when the congregation gradually lost enthusiasm. The hall was then used mainly for social dances, so the citizens met and changed the name of the building to Newtown Hall. In 1883, through the efforts of many Newtown citizens, a new hall was built on this site for $5,115.73. In the early 1920s, movies began to be shown, so Newtown Hall was renovated significantly by the Newtown Exchange Club in the spring of 1936. (Courtesy of the Newtown Historic Association Inc.)

Eight
TRANSPORTATION

Newtown was the hub of an extensive road network during the 18th century. The first road from Bristol to Newtown was opened in 1693. In 1703, it was extended from Newtown to Buckingham and, by 1745, it had reached Durham Furnace. The Philadelphia, Newtown, and New York Stage was operating in 1799. Although Bucks County had been settled many years before any public conveyance ran through it, the main public means of travel for some time was confined to the river and its banks. In the spring of 1828, John Bessonett and James Hacket and Company carried passengers and mail from Philadelphia to Bristol by steamboat, where they took stagecoaches to Easton via Newtown, Lumberville, Point Pleasant, and Erwinna. In 1872, the Philadelphia, Newtown, and New York Railroad Company was organized. On June 8, 1872, as many as 500 people from Newtown witnessed the moving of the first wheelbarrow load of dirt during the inaugural groundbreaking at Crescentville in Philadelphia. Newtown made one of its most advanced steps on December 17, 1896, by incorporating the Street Railway Company and building a trolley road to Langhorne, which connected to Bristol. Newtown electric trolley service began on December 21, 1897. Several trial runs over the line allowed Newtown residents to enjoy free rides in the afternoon. Today, we still use a road network in and around Newtown that originated, in part, before our European forebears arrived here, since our main arteries today are the successors to a labyrinthine system of Native American trails very much in place when Newtown's life began.

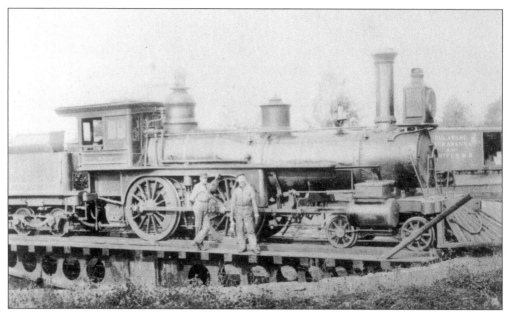

NORTH PENN LOCOMOTIVE NO. 455, "TELFORD," 1886. The "Telford" is shown on the Newtown line of the Philadelphia, Newtown, and New York Railroad. The locomotive is on the old Sellers turntable, which was located on the property at 507 South State Street. Frank Rook, the fireman, is on the left and Joe Paul, the engineer, is on the right. In the lower right is a wooden crossbar that was used to rotate the turntable by hand. (Courtesy of the Newtown Historic Association Inc.)

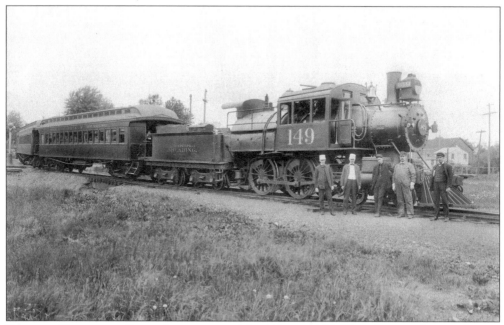

READING CAMELBACK STEAM LOCOMOTIVE NO. 149, C. 1900. This photograph was taken on the west leg of the wye track as one coach and one combination car were ready for return trip to Philadelphia. Note the water "plug" on the left in the background and Centre Avenue on the right in the background. (Courtesy of the Newtown Historic Association Inc.)

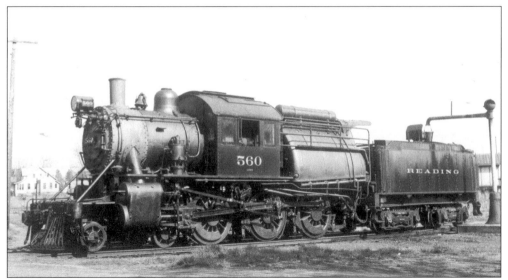

READING CAMELBACK STEAM LOCOMOTIVE NO. 560, C. 1900. This locomotive is also on the west leg of the wye track at Newtown, taking water at the "plug" near Centre Avenue. Originally built in May 1898 as No. 187, this locomotive was renumbered as No. 560 in 1900 and scrapped in November 1945. The locomotive is facing Centre Avenue prior to being turned around on the turntable for the return trip to Philadelphia. No. 560 was being used in light passenger service at the time of this photograph. (Courtesy of the Newtown Historic Association Inc.)

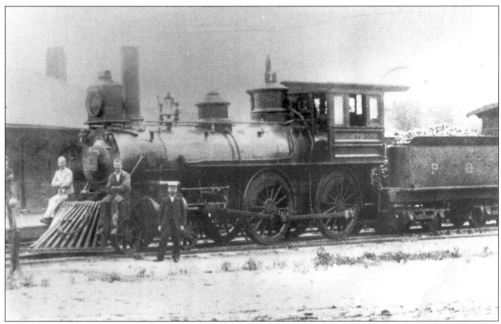

PHILADELPHIA AND READING STEAM LOCOMOTIVE NO. 479, C. 1900. Locomotive No. 479, originally named "Langhorne," was built in November 1875 and was put into service on December 1. When the Philadelphia and Reading Railroad acquired the North Pennsylvania Railroad in May 1879, the designation of the locomotive changed from "Langhorne" to No. 479. (Courtesy of the Newtown Historic Association Inc.)

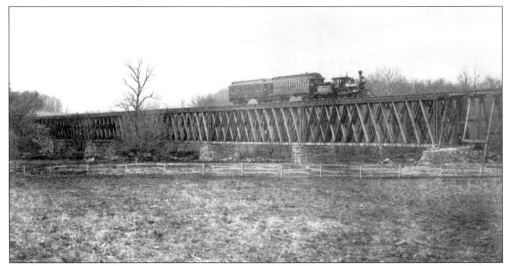

THE NESHAMINY RAILROAD BRIDGE, APRIL 15, 1878. This bridge for the Newtown Railroad crossed over the Neshaminy Creek below the George School. The bridge opened on February 2, 1878, burned in July 1904, and was then replaced by steel. The *Newtown Enterprise* of Saturday, April 20, 1878 reads, "On Monday afternoon, April 15, 1878, photographer E.R. McKean took this photograph of the train of cars on our railroad as it came to a halt for the purpose when on the Neshaminy Bridge." This is the only known photograph of a Pennsylvania Railroad train on the Philadelphia, Newtown, and New York Railroad. (Courtesy of the Newtown Historic Association Inc.)

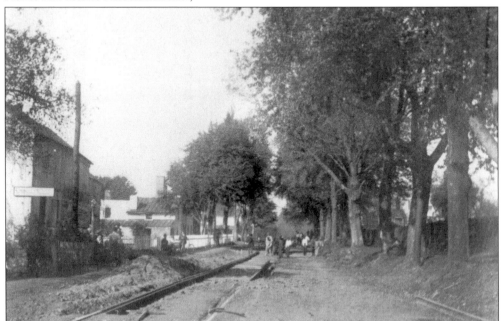

INSTALLATION OF ORIGINAL TROLLEY TRACKS, 1897. This photograph was taken on State Street, north of Jefferson Street. The laying of trolley track commenced on October 4, 1897, at State and Jefferson Streets. The Newtown Electric trolley began service on December 21, 1897, with free rides for Newtown residents in the afternoon. (Courtesy of the Newtown Historic Association Inc.)

THE WOODEN TRUSS BRIDGE, C. 1900. This bridge spanned the Neshaminy Creek near the George School on the Philadelphia, Newtown, and New York Railroad, about a mile south of Newtown. The bridge was one of the largest frame structures on the Reading's Newtown branch. This photograph was taken looking toward the George School Station, which can be seen in the background. (Courtesy of the Newtown Historic Association Inc.)

THE SAME VIEW OF THE BRIDGE, AFTER THE FIRE. Fire struck the bridge in July 1904. According to the *Springtown Weekly Times*, July 9, 1904, "it is supposed the structure was fired by sparks (coal) from a passing locomotive. The announcement of the blaze created considerable excitement and several hundred people witnessed the fire. A temporary footbridge has been erected for the accommodation of passengers. Trains now run to each side of the stream, the passengers walk over. It will no doubt be some time before trains run through, as the bridge is entirely destroyed." (Courtesy of the Newtown Historic Association Inc.)

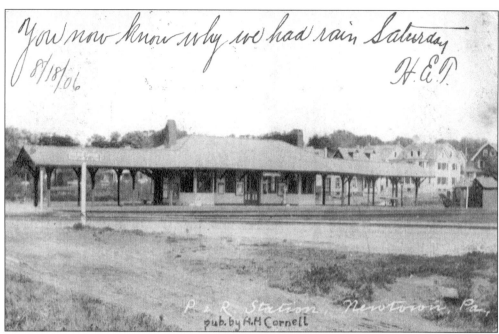

You now know why we had rain Saturday
8/18/06
H.E.T.

P. & R. Station, Newtown, Pa.
pub. by H.M Cornell

NEWTOWN'S SECOND RAILROAD STATION, AUGUST 20, 1906. This station was located at Lincoln Avenue and Penn Street and was used until the 1960s. (Courtesy of the Newtown Historic Association Inc.)

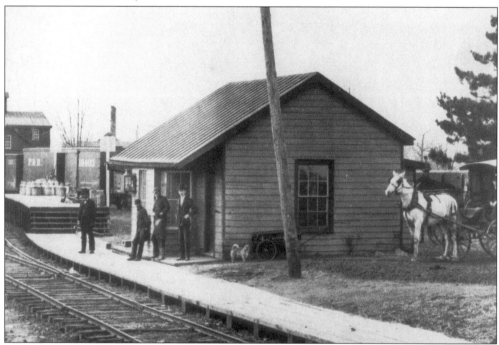

NEWTOWN'S FIRST RAILROAD STATION, C. 1890. This station was located on the west side of the railroad tracks on the west side of South Chancellor Street on the property of William W. Fabian & Son. Bill Hutchinson, who operated the local horse-drawn taxi service, is standing second from left. (Courtesy of the Newtown Historic Association Inc.)

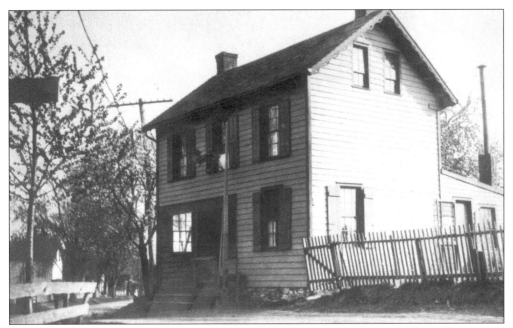

THE NEWTOWN AND WRIGHTSTOWN TURNPIKE TOLLHOUSE, C. 1900. The tollhouse was located at the present site of Goodnoe's Dairy Bar on the corner of Sycamore Street and Durham Road. In 1955, it was moved to its present location at the intersection of Eagle and Durham Roads. (Courtesy of the Newtown Historic Association Inc.)

JOHN S. FENTON MOTORCYCLE, SEPTEMBER 1908. This motorcycle was manufactured in Newtown, most likely near Fenton's residence at 144 Liberty Street. (Courtesy of the Newtown Historic Association Inc.)

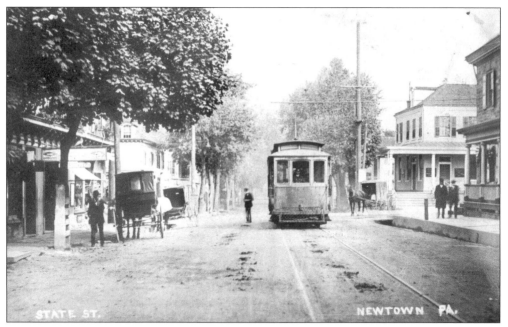

NEWTOWN TROLLEY, SEPTEMBER 27, 1917. The trolley is stopped on State Street, near Washington Avenue. Note the Brick Hotel on the right. The herdic (horse-drawn taxi) on the left met travelers at the train station and served as the local delivery service. (Courtesy of the Newtown Historic Association Inc.)

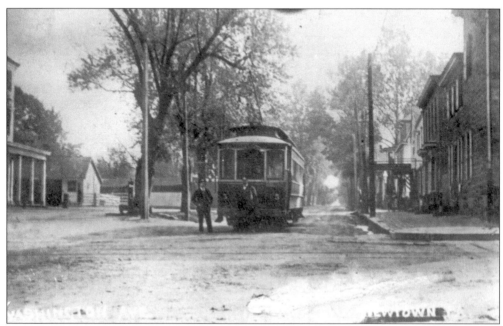

"OLD NO. 5," C. 1907. This photograph shows Car No. 5 of the New Jersey and Pennsylvania Traction Company as it lays over on Washington Avenue at State Street, preparing for a trip to Trenton. (Courtesy of the Newtown Historic Association Inc.)

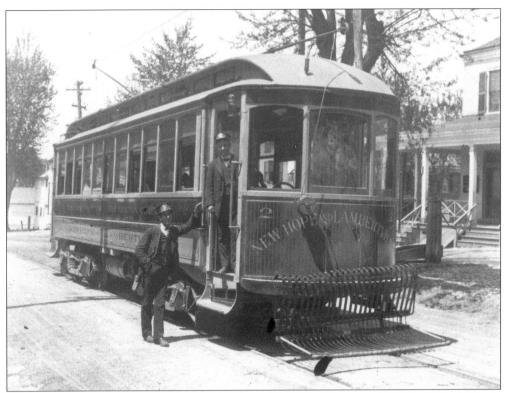

NEW JERSEY AND PENNSYLVANIA TRACTION CAR NO. 2, SPRING 1905. The trolley is stopped facing east on Washington Avenue in front of the Brick Hotel at the intersection of State Street. (Courtesy of the Newtown Historic Association Inc.)

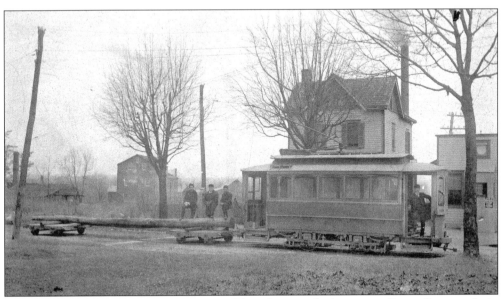

TROLLEY LINE UTILITY WORK, C. 1910. This photograph shows a trolley pulling a pole in front of the trolley office at 348 South Lincoln Avenue. To the right of the office is the trolley repair shop. (Courtesy of the Newtown Historic Association Inc.)

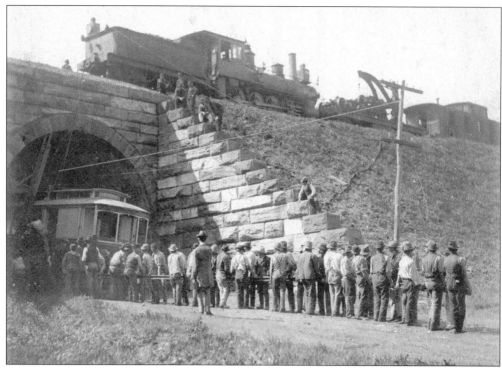

A Transportation Confrontation, Friday, May 12, 1899. Pictured are workmen about to lay trolley tracks under the bridge of the Trenton cutoff of the Pennsylvania Railroad north of Langhorne on the Bridgetown-Newtown Turnpike. The Pennsylvania Railroad did not want the Newtown Electric Street Railway Trolley line crossing beneath its line. This resulted in a serious physical confrontation between workmen from the two sides. (Courtesy of the Newtown Historic Association Inc.)

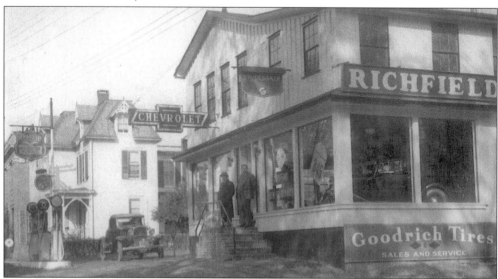

Balderston's Studebaker and Chevrolet Dealership, c. 1932. This dealership was located at 215 South State Street. Albert Balderston is shown standing on the steps. (Courtesy of Ann Balderston, Newtown, Pennsylvania.)

A MODEL T FORD, C. 1918. Shown is Louis Wettling's car parked at about 154 North State Street, just south of Jefferson Street. The car is a virtual moving advertisement for investing in U.S. Bonds to support the World War I effort. (Courtesy of the Newtown Historic Association Inc.)

A MODEL T TOURING CAR, 1914. This car is parked in front of 159 North State Street. The boy on the tricycle is Hounten Schofield, with Mrs. Voorhees looking out the window and Meta Randall in the back seat. (Courtesy of the Newtown Historic Association Inc.)

BIBLIOGRAPHY

Area Guidebook: The Original and the Only Guide to Historic Bucks and Hunterdon Counties, Vol. XXVI. 1995–1996 Edition.

Barnsley, Edward R. *Agricultural Societies of Bucks County*. July 1940.

———. *Historic Newtown*. June 1934.

———. *Snapshots of Revolutionary Newtown*. 1940.

Blackburn, Bruce B. "Newtown: A Village with Heritage and Heart." *Nouveau Delaware Valley Magazine*, Vol. XVII. June 1997.

Bucks County Fireman's Association. 71st Annual Parade. June 9, 1984.

Callahan, C. David, Paul M. Gouza, and Brian E. Rounsavill. *Early Newtown: A Pictorial History of Newtown, Pennsylvania*. July 1999.

Campbell, Elinor Slack. *A History of the Newtown Presbyterian Church, 1734–1900*. 1994.

Celebrating 100 Years, 1897–1997, Historical 100th Anniversary Journal of St. Mark AMC Zion Church. 1998.

Davis, William W.H. *History of Bucks County, Pennsylvania*. 1905.

Foesig, Harry, Barker Giummere, and Harold E. Cox. *Trolleys of Bucks County, Pennsylvania*. 1985.

George School, Alumni Association. *History of George School, 1893–1943*. 1943.

Gummere, Barker and Gary Kleinedle. *Trenton-Princeton Traction Company, Pennsylvania and New Jersey Railway*. 1965.

"New Century Club, Historic Newtown," The *Newtown Enterprise*. 1923.

Newtown 275th Anniversary, Newtown, Pennsylvania, 1684–1959.

Newtown 1684–1984: A History of Newtown, Pennsylvania as Prepared for the Celebration of Its 300th Anniversary.Jostens Inc, 1983.

Newtown Enterprise, various issues. Newtown, Pa. March 19, 1868–October 29, 1970.

"Newtown Historic District." *Report to the Department of the Interior for Nomination to the National Register of Historic Places*. 1979.

Newtown Joint Historic Commission. *A Preliminary Report on the McMasters House*. 1994.

Newtown Then. . . . Bucks County Association for the Blind Inc. 1976.

"Newtown, U.S.A.: A Tribute to a Small Town on Its 175th Anniversary." *Pennsylvania Traveller*. June 1959.

Swayne, Kingdon W. *George School: The History of a Quaker Community*. 1992.

This is Newtown. League of Women Voters of Newtown. 1952.